Latin American Art

Latin American Art

An Introduction to Works of the 20th Century

by

Dorothy Chaplik

with a foreword by
ANGEL HURTADO

McFarland & Company, Inc., Publishers
Jefferson, North Carolina, and London

British Library Cataloguing-in-Publication data available.

Library of Congress Cataloguing-in-Publication Data

Chaplik, Dorothy
 Latin American art.

 Bibiography: p. 151.
 Includes index.
 1. Art, Latin American. 2. Art, Modern – 20th century –
Latin America. I. Title.
N6502.5.C44 1989 709'.8 88-42645

ISBN 0-89950-363-2 (lib. bdg.; 60# Finch Opaque and 70# enamel gloss papers)

Printed in the United States of America.

McFarland & Company, Inc., Publishers
 Box 611, Jefferson, North Carolina 28640

To the schoolchildren of Latin American lineage
who inspired my interest in their rich heritage.

Acknowledgments

Warm thanks are given to my husband, Seymour Chaplik, for his enduring support, and to my friend, Lucrecia A. Bernal, for her perceptive reading of the manuscript and her valuable suggestions.

D.C.

Contents

Foreword

The analysis of works of art is a task both difficult and dangerous. The difficulty resides in the fact that since today no rules are imposed on artistic creation, no fixed standards exist for judgment. The danger lies in the ease with which the critic can fall into the trap of misinterpretation. As the appreciation of artistic values is a purely subjective matter, the critic's personal feelings may lead to "seeing" in a work images or concepts which never entered the mind of the artist, either before or during the process of creation.

There is also the possibility that a good analyst may find in a work more than the artist intended to convey. The analyst may discover reflections of concerns of which the artist was quite unconscious—concerns which are nonetheless apparent to the perceptive eye—and attribute to them exaggerated importance.

These, then, are the problems and perils which the writer confronts in the appreciation of works of art.

Dorothy Chaplik has been most skillful in avoiding all of these pitfalls. Her analyses are the product of patient and tenacious research, long study, and measured reflection; they evince both serious scholarly commitment and a genuine love for her topic. I can say this with assurance, for I have been acquainted with her work since its beginnings and, speaking as one of her subjects, I find her analysis altogether admirable.

It was in 1974 that Dorothy Chaplik came to the Museum of Modern Art of Latin America with the idea for her book and materials representing her preliminary research. While she entertained doubts on a number of scores, she nourished strong hopes of one day seeing her book in print. Undaunted by the difficulties of obtaining source material, she has ever since pursued her labor of love with rare devotion, consulting every font of information, traveling, interviewing artists, and writing innumerable letters to South America (the majority of which I venture to guess went

unanswered). Most important of all, she has engaged in lengthy, detailed, objective study of the work of each of her subjects, writing analyses which are distinguished both for the depth of her knowledge and the keenness of her intuition. The perceptiveness of her judgment is betokened by the fact that a number of the artists who attracted her attention as early as 1974 had not then been "discovered" by United States critics in general.

I confess that thirteen years ago, when the author interviewed me for her book, I viewed the project with a certain amount of skepticism. Any treatise on art presents its problems, and when the subject is Latin American art, their number is inestimable. Dorothy Chaplik's persistence, however, has overcome all obstacles.

In 1974 interest in Latin American art was nothing like it is today. There has been a decided improvement in this respect, though I regret to say that the reason for it is largely commercial in origin. At recent auctions in New York, the prices of certain Latin American compositions have reached astronomical figures, and the public could not fail to be impressed. While legendary names such as those of Rivera, Orozco, Tamayo, Lam, Portinari, and Matta continue to dominate the field, the work of Pettoruti, Reverón and Di Cavalcanti are gaining recognition; and as artists of the next generation, including Grau and Soto, for example, make headway, they are joined by such juniors as Cuevas, Toledo, Dario Morales, and Armando Morales.

There has been an increasing number of individual and collective exhibitions of Latin American art at important museums and galleries, the most significant to date being the one which opened in June 1987 at the Indianapolis Museum of Art—an exhibit which then circulated to other institutions both in the United States and in Mexico. The show covers the period from 1920 to the present, and many of the artists included figure in Dorothy Chaplik's book. I am convinced that her study will serve to stimulate still greater interest in an area of art which up to now has been unduly neglected.

Latin American Art is destined to be an indispensable reference tool in every art library of significance, because of not only the surety of the author's critical analysis but also the biographical information provided with respect to each of the artists studied, and the valuable bibliography which appears at the end. The number of books, articles, and catalogues which the author has consulted is most impressive. I confess I had no idea the material was so extensive, and I am most grateful for having it brought to my attention. As if this were not enough,

Dorothy Chaplik has also included a glossary, which readers should find decidedly useful.

This book will be of interest to students (the author has dedicated it to young people of Latin American lineage), to the art-loving public in general and to specialists, who will find it a more than handy reference work. Dorothy Chaplik is to be warmly congratulated on her effort, and thanks are due to her and her publisher for this contribution to increased understanding and appreciation of art in the southern half of our hemisphere.

<div align="center">

Angel Hurtado
Museum of Modern Art of Latin America
Washington, D.C.

</div>

Introduction

Great differences exist among the Latin American countries, where a variety of people (native, African, European) speak a variety of languages and numerous regional dialects. Climate, terrain and customs are also varied. But binding the countries together are a common historical background and a consistent pattern among the people in expressing themselves through art.

The art and history of Latin America can be divided into three periods: pre-Columbian, colonial and modern. The sixteenth century Spanish conquest caused the collapse of native civilizations throughout the hemisphere, ending the pre-Columbian period and marking the start of the colonial period, a time of Spanish and Portuguese domination. During the nineteenth century, wars of independence were fought that broke the rule of Spain and Portugal and led to the modern period.

Each epoch has been culturally rich. Artistic creation during ancient Indian times and the colonial period is well documented, but the art of the modern era, still comparatively young, is less known. As the illustrations in this book testify, Latin America's twentieth century art is as varied as the land and the people. But let us consider for a moment the very nature of modern art.

Unlike earlier art, which was dictated largely by religious beliefs, modern art is often a personal statement—a reflection of life as seen through the eyes of individual artists. They observe people, themselves as well as others; they study actions and reactions, dreams, thoughts and feelings; they contemplate nature; and they record what they see in some unique way. To express themselves, artists choose from a variety of materials, including paper, cloth, wood, stone, metal, paint, pencil and ink. The finished work of art is a communication from the hand of the artist to the eye of the viewer.

How artists feel about their subjects is an important aspect of their

communication. For example, in a portrait of a mother and child, an artist can show pleasure in the loving relationship between them. In a battle scene, an artist can express admiration for a soldier's courage, or sorrow for the cruelty of war.

Lifestyles may differ around the world, but the emotions of people everywhere are the same: joy and sorrow, love and hate, anger and pleasure. The viewer must look beyond the objects in a picture to read the feelings of the artist, which become the special language of art that all persons can understand, no matter what spoken language they use. For example, Mauricio Lasansky's *Self-Portrait* (page 6), with its detailed head and hands, reveals pride and self-satisfaction. In *The Studio of Diego Rivera* (page 10), the painter (Rivera) uses Mexican folk art to create a mood of sadness to sustain the grave tenor of the reclining woman.

Besides expressing feelings, artists often describe life in their countries—perhaps their history, geography, architecture, customs, religion or politics.

In an indirect way, Rufino Tamayo describes Mexico. In *Watermelon* (see color insert), he paints fruit on a table in the corner of a room. Watermelon and apples are found in many countries, but through his unique handling of color, Tamayo reveals aspects of Mexico. The pinkish-red glow is a reminder of the color of Mexican folk art and Mexican walls, of the warmth of Mexico's climate and the luscious fruits it grows.

In a direct, factual way, José Antonio Velásquez describes the life around him in Honduras. In *San Antonio de Oriente* (page 24), he shows minute details of his village.

Some artists take liberties with what they see by rearranging nature or by changing real objects into unreal forms. In *Huanacaúri* (see color insert), Fernando de Szyszlo of Peru transforms the ancient ruins of his Inca ancestors into imaginary shapes. The forms represent the sacred stones and hills of Cuzco.

Modern transportation and communication unite artists from different parts of the world. Those from the smallest, most remote villages can share knowledge with artists from large cities, through art books and magazines printed in many languages and sent all over the world, and through exhibitions. When new art styles emerge, they can be carried quickly to art centers such as those in Venice, New York or São Paulo, where visitors from isolated areas can come to see them. Inspired in this way, artists may adopt contemporary, international art styles; or they may reject new trends and continue to work in their traditional styles.

Whatever their style—contemporary or traditional, realistic or imaginative—artists use the same basic elements and principles to create a picture. The basic elements are *line, shape, space, light, color* and *texture*. In arranging the elements in a composition, an artist is guided by certain principles: *pattern, rhythm, contrast, balance* and *unity*. By learning to look for these components, the viewer comes to a better understanding of the work of art.

But there is also something in every creation that cannot be described in words. Study a work of art carefully. You will find the special meaning each person discovers when quietly looking at a picture alone.

1. —————————————— Line

• **Self-Portrait.** *Mauricio Lasansky (born Argentina, 1914). Intaglio engraving, 1957.*

The artist has not flattered himself in this portrait. He might have chosen to stand directly in front of the viewer, well-groomed and in his best clothes. Instead he has given us an informal glimpse of himself, calling attention to an uneven profile, an expanding waistline, and the need of a shave and haircut. Yet he looks pleased and self-satisfied.

Because the figure occupies most of the paper's space, and seems almost life-sized, you may get the feeling you can talk with Lasansky. By stressing his hands and head, the artist seems to be saying that these precious possessions have become stronger over the years, despite unflattering changes in less important parts of his body.

Lasansky's self-portrait demonstrates *line* as the edge of shape. At the front of the torso, line is unbroken and flowing, but the artist's back and the inner part of his arm are drawn with broken sections of line. Some of these short lines indicate folds in the fabric of his shirt, while heavier lines and a bit of color emphasize his head and hands, parts of the body especially important to an artist. The lines of the upright fingers of the bottom hand direct your eyes upward to the artist's head; the front outline of the shirt guides you along, while the details of his face and hair keep you busy looking.

• **Fallen Knight (Caballero vencido).*** *Guillermo Silva Santamaría (born Colombia, 1921). Intaglio print, hand colored, 1961.*

*See color insert.

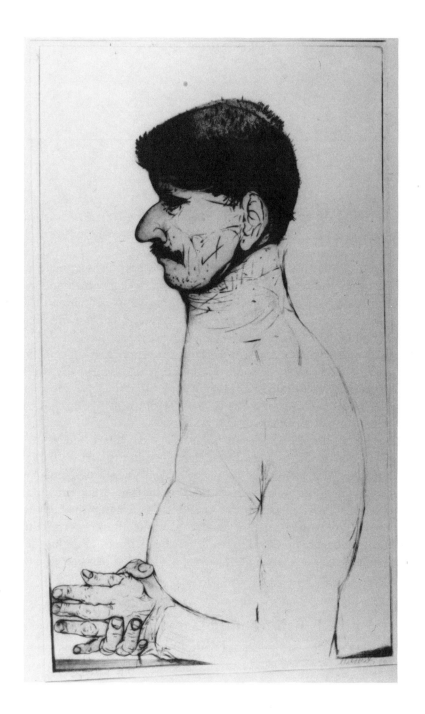

Mauricio Lasansky. *Self-Portrait*. Intaglio engraving, 1957. Courtesy of the Art Institute of Chicago. Gift of Print and Drawing Club. (Photo by Seymour Chaplik.)

Such rich colors and designs seem appropriate for a victory celebration. They make the plight of the fallen soldier especially tragic. The horse is rearing his head and you can almost hear a mournful cry, while the warrior's armored body has fallen into a posture of death and defeat. Did Silva intend the knight to be a symbol of the Spanish conquistador?

Silva used *line* to separate one color from another and one shape from another. Clean, crisp lines divide the red patch on the horse's neck from the black portions. Curved lines divide the different sections of the rider's armor.

A variety of lines, straight and curved, thick and thin, create designs on the body armor, the head piece, and the shield. Even the horse's neck and legs and the warrior's lance are strong lines working to balance the downward pull of the knight's falling body.

The artist's choice of curved and straight lines, instead of naturalistic ones, gives the horse and rider a stylized design.

• **Mother and Child.** *Wifredo Lam (born Cuba, 1902; died 1982). Pastel drawing, 1957.*

Gentle, curved *lines* help to set the mood for serene and tender portraits of mothers and children the world over. Lam accomplished this in spite of the strangeness of the figures. They seem half animal or bird, with faces like masks. Yet the mother is convincingly natural and maternal in the curves of her neck and back, the ease which which she sits on a chair and the close, familiar way she holds her young one, double-headed though it is. Notice how curved lines unite the child's body with the mother's.

A sketchy figure in the background is close to being a human child, but it has animal features hinting of horns and tail. Mother, children and chair—all are created with sweeping curved lines.

Born and raised in Cuba, Lam knows well the African voodoo cults practiced there. He understands primitive beliefs in gods that are part animal and part human, in a world of fetish figures and masks, in magic and mystery. That world is incorporated here in a way that expresses the spirit of some of the people from his own country. At the same time, the mother and child theme can have meaning to people everywhere.

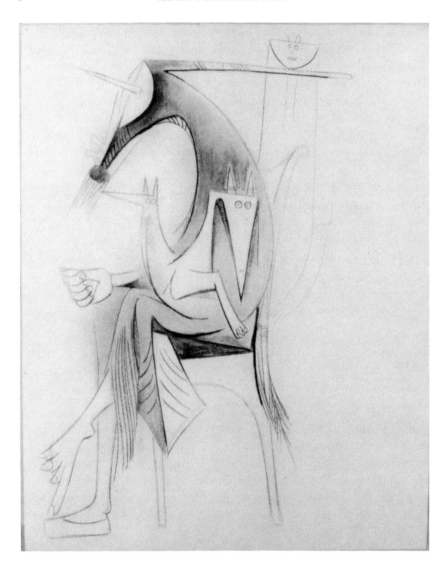

Wifredo Lam. *Mother and Child*. Pastel drawing, 1957. Bergman collection, Chicago, Ill. (Photo by Seymour Chaplik.)

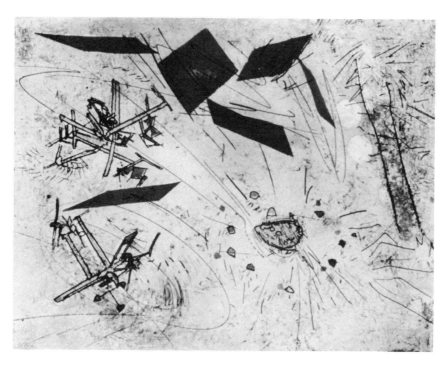

Matta. *Untitled Etching.* Undated. Courtesy of the Art Institute of Chicago. Gift
of Alan Frumkin, 1960. From Frumkin portfolio. (Photo by Seymour Chaplik.)

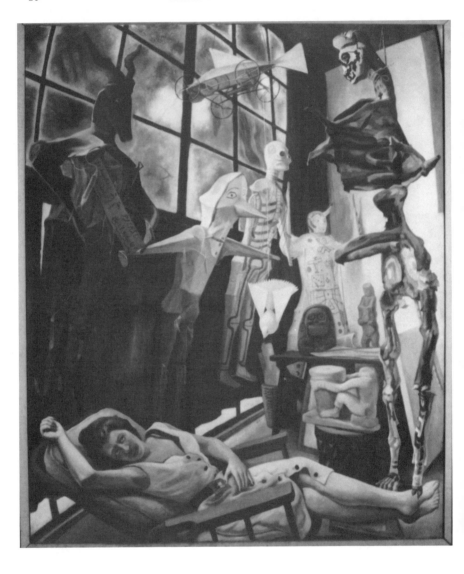

Diego Rivera. *The Studio of Diego Rivera (El estudio de Diego Rivera)*. Oil on canvas, 1954. Courtesy of Museo de Arte Moderno de Mexico. (Photo by Paulina Lavista.)

- **Untitled Etching.** *Matta (born Chile, 1911). Undated.*

Are you looking at the center of a cyclone? Has there been an accident in space? An atomic explosion? Objects are swirling in space, some on a collision course; others look as if they have already collided or exploded. Complex machines on the left, for example, seem to be falling apart. The spatial atmosphere is familiar, yet unreal.

Much of the whirling movement was created by Matta with *lines*. Diagonal lines are full of action, unlike the quiet, gentle quality of curved lines or lines that are horizontal and vertical. Short bits of line have exploded all over the surface, while long scribbly lines take you on a roller-coaster ride through space. Some of the rectangular shapes are bent out of kilter, floating off-balance. Even the background space seems to move with its contrasts of light and dark.

Preoccupied with movement and atmosphere, Matta is very much a Space Age man. At the same time, consider his native country, a land of volcanoes, torrential rains and seaquakes. Perhaps Matta's explosions of line, shape and color grow out of early memories of Chile.

- **The Studio of Diego Rivera (El estudio de Diego Rivera).** *Diego Rivera (born Mexico, 1886; died 1957). Oil on canvas, 1954.*

A corner of Rivera's studio is crowded with eerie sculpture. The lightweight paper men are built on frames of wire and strung with firecrackers. These figures are typical of the folk art usually made at home and seen in Mexico during certain fiestas. The smaller, heavy-looking figures were probably made of clay or stone by ancient Indian artists living in Mexico before the Spanish Conquest. During his lifetime, Rivera collected both types of art and often used them as models when he painted. In this picture, the assorted pieces of sculpture cast a ghostly light all about them.

Notice the hanging figures. The shapes of their legs stand out against the background. They become *lines* that direct your eyes to the bottom of the picture, where you discover a woman stretched out as if in pain. Now the unusual props have a second meaning. Not only is the idea of death found frequently in Mexican folk art, but in this painting, Rivera used the sculpture as a symbol for the death of his own wife, Frida Kahlo, in 1954, the year in which he painted the picture.

2. ——————— Shape

• **Women in the Field.** *Francisco Zúñiga (born Costa Rica, 1912). Watercolor, 1966.*

Shawls in the *shape* of pyramids protect these women from the heat of the sun. Sad yet dignified, they wear their shawls with the majesty of queens, but their large, bare feet are reminders that they work in the fields for a living. Seated on the ground, the women seem to get strength from the same earth that nourishes the fields they tend.

To the people of Central America and Mexico, the pyramid has special meaning. Their ancestors built great pyramid-temples, many still standing, to worship important gods. In art of any kind, the triangle with its broad base at the bottom is a shape that gives the viewer a feeling of strength and stability.

By painting the women in shawls, Zúñiga could emphasize the strength of the women in another way. With their bodies hidden beneath *rebozos* (shawls), their expressive faces and feet hold your attention.

• **Last Light.** *Omar Rayo (born Colombia, 1928). Relief print, undated.*

Now you see it, now you don't. There are two ways of looking at this picture: as a common, everyday object or as a group of related *shapes.* There are several triangles, a large square and a rectangle. An inverted "V," rounded at one end, extends from the right side. On closer inspection, the "V" is actually a bent match, the only one remaining in a cardboard pack.

Part of Rayo's skill is in his ability to change a simple household item

Above: Omar Rayo. *Last Light.* Relief print, undated. Courtesy of the Art Institute of Chicago. Gift of Joseph R. Shapiro. (Photo by Seymour Chaplik.)

Opposite: Francisco Zúñiga. *Women in the Field.* Watercolor, 1966. Illinois Bell Corporate Collection. (Photo courtesy of Illinois Bell, Chicago, Ill.)

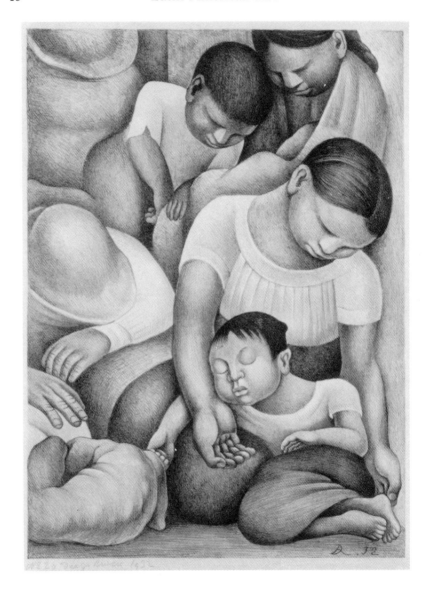

Diego Rivera. *Sleep*. Lithograph, 1932. Courtesy of the Art Institute of Chicago.

into a monumental art form. Without recognizing the subject, you can enjoy its mathematical precision. Will you ever look at a match pack again without seeing its geometric lines and shapes?

To make the original print, Omar Rayo prepared his paper with careful application of red ink. In the printing process, except for the black areas, he used no ink. The metal printing plate was cut so that the pressure of the plate on paper indented some surfaces and raised others. The result was a series of raised shapes, with no ink used for their outlines.

• **Sleep.** *Diego Rivera (born Mexico, 1886; died 1957). Lithograph, 1932.*

A mosaic of people is built of sleeping forms. Their closeness suggests the togetherness of a family. Arms and legs intertwine, heads rest on one another or nod in a relaxed way. Diego Rivera based this picture on a mural he painted in the 1920s, during the Mexican Revolution. (The mural was painted on the outside walls of the Secretariat of Public Education in Mexico City, where it can be seen today.) The scene was called "A Night of the Poor," and Rivera intended it to represent forces of "good," meaning work, unity and love.*

Sympathetic feelings are expressed through *shapes*, as well as through textures and shades of colors. Arms, legs and necks are drawn in the shape of simple cylinders, and your eyes can move easily up and down these columns, observing the gentle ovals of each head. Textures are soft and smooth in skin, hair and clothing. Even the large hands, surely hardened by heavy labor, seem tender in sleep.

Curved lines and shapes and smooth textures always contribute to a spectator's restful feelings. In addition, Rivera used gradual shades of gray, from light to dark, to guide you quietly from one area of the picture to another.

• **Le-Lo-Lai.** *Lorenzo Homar (born Puerto Rico, 1913). Tempera with oil glazes, 1950–51.*

*Antonio Rodríguez, A *History of Mexican Mural Painting*, 1969.

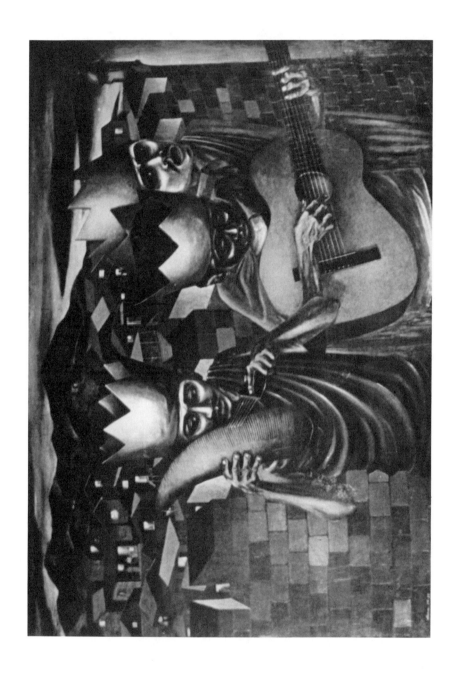

Dressed as the Three Kings, young children perform in front of the wall of the San Cristóbal Fort. They are thin and hungry-looking and have turned their backs to their homes in the slums of La Perla. Following an old folk tradition, Puerto Rican children at one time would practice long and hard in order to play for a few pennies at Christmastime. The hands and faces of these young people show their desperate earnestness.

Jagged *shapes* and curved *shapes* helped the artist create the bittersweet tone of this painting. Notice the cut-out peaks of the homemade crowns, and similar triangular shapes among the rooftops in the background. Crowded together, pointing in different directions and spotted by light, these busy shapes can create a feeling of agitation and unrest in the viewer.

The rounded parts of the crowns are more satisfying to observe. Other curving shapes are found in the mountains, in the guitar and in the folds of the boys' costumes. The wall of the fort is also slightly curved, while the steady rows of rectangular bricks provide a pleasant pattern of another shape.

Lorenzo Homar took liberties here with Puerto Rico's landscape. When facing the wall and the ocean, you cannot actually see the mountains, but Homar's love for the mountains prompted him to include them here.

• **Breakfast (El desayuno).** *Pablo O'Higgins (Mexican citizen, born U.S.A., 1904; died 1983). Oil on canvas, 1945.*

Stopping for their morning meal, a group of construction workers gathers in a close circle. They crouch on their heels or sit on planks of wood beneath the structure they are building. Cross beams appear to frame part of the group, inviting you to examine the men more carefully. Though the artist used broad brush strokes and painted few details, he gave the men a familiarity that suggests you know just how they look and would recognize them, should you meet them somewhere again.

Built with geometric *shapes*, the painting is as sturdy as the structure going up. Partly this sturdiness is due to the combined weight of the men

Opposite: Lorenzo Homar. *Le-Lo-Lai.* Tempera with oil glazes, 1950–51. Courtesy of University of Puerto Rico, Río Piedras. (Photo by Max Toro.)

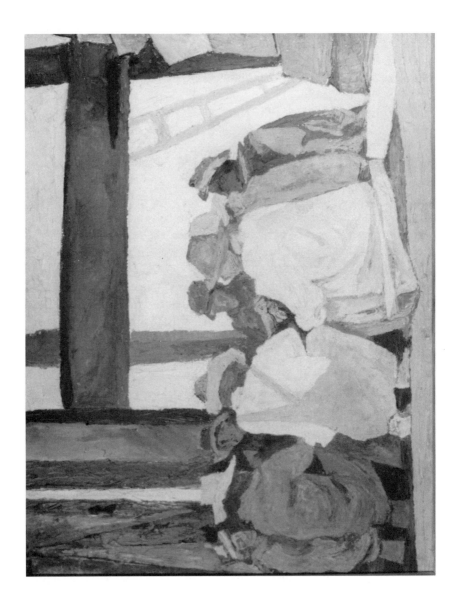

and the triangular-shaped planks at the bottom of the picture that give visual stability.

In addition, the area above the men is composed of interlocking shapes. The strong beams and girders going up and down and crosswise are shaped as rectangles, and so are the spaces around them, while triangular shapes peer out from "hidden" places.

Pablo O'Higgins balanced straight-edged shapes with the curve of the circle in which the men sit, and with the curving lines in the shapes of their hats.

Opposite: Pablo O'Higgins. *Breakfast (El desayuno)*. Oil on canvas, 1945. Courtesy of Museo de Arte Moderno de Mexico. (Photo by Paulina Lavista.)

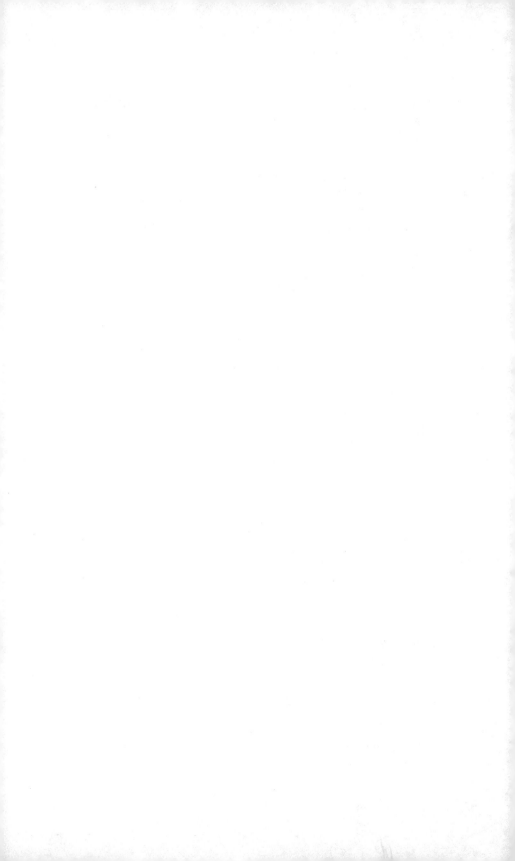

3. ——————————— Space

- **View of San Antonio de Oriente.** *José Antonio Velás-
quez (born Honduras, 1906; died 1983). Oil on canvas, 1971.*

A narrow dirt road invites you to enter the village of San Antonio de
Oriente. White walls and red tile roofs guide you into the painting's deep
space, past treetops and a twin-towered church, to the pine-covered moun-
tains and sky beyond.

When artists begin a picture, they face a flat, blank surface. They
choose a way to create the illusion of space on the paper or canvas they
are using. Velásquez chose to create wide-open space, allowing you to see
in a single glance as much as possible of the village he loved.

A high skyline helps to establish deep space in a landscape painting,
and shadows also contribute to a sense of spatial depth. Notice how the
building walls catch the sun's light, but under each jutting roof is an area
of shadow. The light-filled treetops also are bordered with shadows
beneath their foliage. Although rooftops and trees are nestled close
together, their dark shadows suggest the existence of greater space.

Still another way of achieving space is to make background objects
small in size. While you can be fairly certain that the church in the distance
is larger than the house on the left, its smaller size makes it seem farther
away. As an untrained artist, Velásquez knew nothing of the rules for
perspective taught in schools, but his artist's eye directed his placement of
objects in space.

- **The Great Colonel (El coronelazo).*** *David Alfaro
Siqueiros (born Mexico, 1896; died 1974). Pyroxylin on masonite,
1945.*

*Fighting in Spain's Civil War in 1935, Siqueiros was made a lieutenant colonel in
the Republican Army, and was nicknamed El coronelazo.

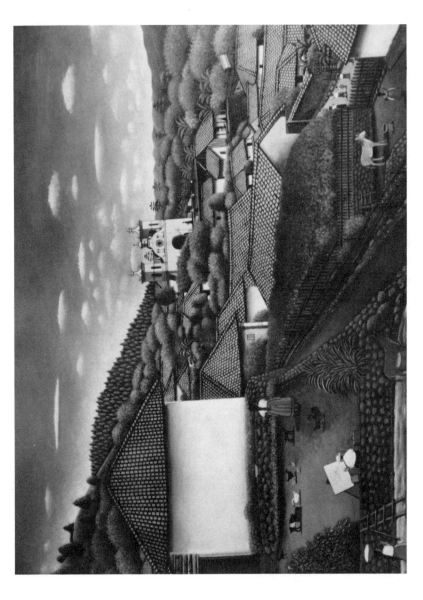

José Antonio Velásquez. *View of San Antonio de Oriente*. Oil on canvas, 1971. Collection of Ambassador and Mrs. Gonzalo García Bustillos, Washington, D.C. (Photo by Angel Hurtado.)

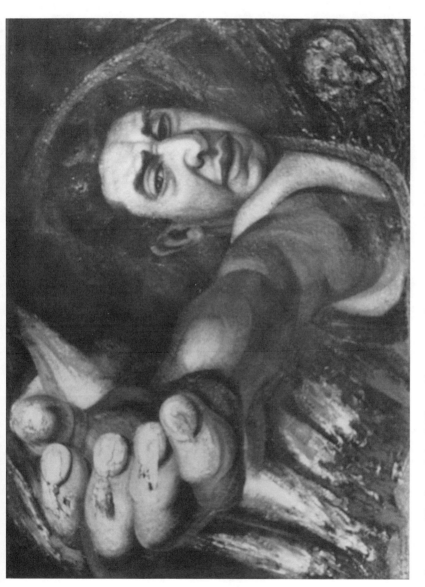

David Alfaro Siqueiros. *The Great Colonel* (*El coronelazo*). Pyroxylin on masonite, 1945. Courtesy of Museo de Arte Moderno de Mexico. (Photo by Paulina Lavista.)

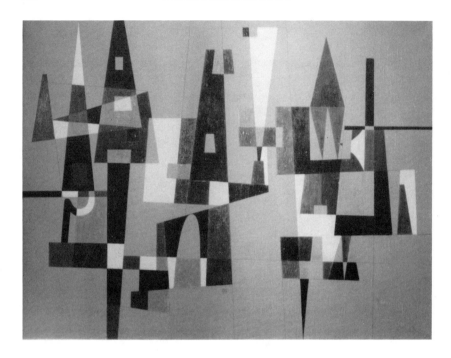

Carlos Mérida. *City Landscape No. 1 (Paisaje de la urbe no. 1)*. Oil on canvas, 1956.
Collection of Galería de Arte Mexicano. Courtesy of Museo de Arte Moderno de
Mexico. (Photo by Paulina Lavista.)

Bursting from the picture, the artist's coiled fingers drip with paint. Everything in this self-portrait reflects strength and power—the exaggerated hand, the rippling arm muscles, the determined face and even the background *space,* as it whirls with the force of a volcano.

While Velásquez led you gently into the deep background space of his landscape, Siqueiros boldly thrusts his hand forward through the picture space and out at you. He created this illusion by contrasting light areas against dark areas.

Swirling lines and shapes and rough-textured paint help express the artist's great emotions. The paintbrush is usually considered an extension of the artist's fingers, but Siqueiros went a step further and showed paint oozing from his fingertips.

Since pyroxylin is used in factories, Siqueiros thought it was an appropriate paint for an artist devoted to the working people. Most of his smaller easel paintings, such as this one, were preliminary studies for large murals, painted on the walls of public buildings, which spoke easily to the crowds of passers-by. For Siqueiros, all of art was a social cry, a way to move people to thought and action.

- **City Landscape No. 1 (Paisaje de la urbe no. 1).** *Carlos Mérida (born Guatemala, 1891; died 1984). Oil on canvas, 1956.*

A group of flat shapes touch each other and sometimes overlap. There are many triangles—right side up, upside down, sideways. Are they pyramids? Towers? Steeples? Or are they the shapes of streets, garden walls and courtyards as seen from above? From the title you know Carlos Mérida has painted a city landscape, but he has reduced the scene to geometric shapes. You seem to view things from several levels of *space* at once—as from an airplane, a high building, a bus window, or a walk on foot.

Although the painting appears to be flat, the artist created a feeling of some space. This comes partly from the overlapping of some shapes. A few shapes were made transparent, allowing you to see the overlapping more clearly. In other places he used open shapes, or voids, suggesting windows, doors and passageways that allow the pale orange background space to come through.

Although Mérida changed a city scene into geometric forms, he kept enough identity in them to recognize bits of Spanish American

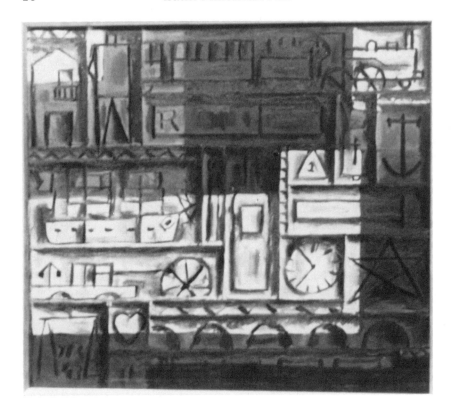

Joaquín Torres-García. *Constructivism*. Oil on canvas, 1943. Gift of Nelson Rockefeller. Collection of the Museum of Modern Art of Latin America, Organization of American States, Washington, D.C. (Photo by Seymour Chaplik.)

architecture. *Zócalos* (city squares), church towers and an arched doorway peer out at you.

Not by accident, Mérida's modern arrangement of forms in space resembles the designs found in old Indian weavings from Guatemala and Mexico.

• Constructivism. *Joaquín Torres-García (born Uruguay, 1874; died 1949). Oil on canvas, 1943.*

A number of objects, each boxed in its own *space*, are painted inside a large framework. A house with a Spanish balcony is at the top left, and next to it is a geometric man. There is a train, a boat, an anchor, a bridge and more. Geometric lines and spaces separate them, but together these things describe the atmosphere of a particular place – a scene another artist might have painted in a more familiar way.

At first glance the background space of each small box appears flat, but depth begins to take form when you notice the rim of shadow around the clock's square frame, or the shadowy areas around the train and boat. This is not the deep space of Velásquez, nor the flat space of Carlos Mérida. This background has the depth of a shallow box.

Torres-García drew things in a simple, childlike way in order to make them clearly understood by all people, wherever they live. Whether their own home is a primitive hut or a city apartment building, people looking at this painting will recognize "house." The man, too, with his square torso and triangular legs, is "man" in the eyes of all observers.

The artist constructed his painting with horizontal and vertical grids and with blocks of color. He called his style "universal constructivism."

• Maté on the Sidewalk *(Maté en la vereda). Héctor Basaldúa (born Argentina, 1895; died 1976). Lithograph, 1964.*

Seated outdoors, two women face each other as they sip *maté** through straws. Pushed close against the front *space* of the picture, they give us a

*Maté is a common Latin American herbal drink, often served in a gourd with a straw *(bombilla)*. In the small towns of Argentina families sit outside after dinner for a little maté, fresh air and conversation.

good view of their old-fashioned dresses trimmed with ruffles and lace. The exaggerated eye of the woman in profile and the three-quarters pose of the other allow us to see the exchange of glances between them. Have they shared some amusing news?

Space was used by Basaldúa to make the women seem close to us and to each other, but away from the surrounding area. By making the women large and clear and the background shapes small, soft and blurry, the artist created a sense of perspective and space. Street and sidewalk are bare patches of black and gray that separate the ladies from the sketchy building in the background. An expanse of gray sky adds to the emptiness. All this, by contrast, makes the two women seem close and intimate.

Opposite: Héctor Basaldúa. *Maté on the Sidewalk (Maté en la vereda).* Lithograph, 1964. Collection of Dr. and Mrs. Jorge Schneider, Highland Park, Ill. (Photo by Seymour Chaplik.)

4. ──────────── Light

- **Watchful Image – Inés II (Estampa vigilante – Inés II).** *Francisco Rodón (born Puerto Rico, 1934). Oil on canvas, 1970.*

In this radiant atmosphere what secret thoughts occupy Inés? Her mind seems far away as she kneels in the midst of a flourishing garden. Bright sunlight reveals astonishing red hair and ivory skin, and as it moves across the painting, *light* touches the tops of leaves and produces patterns of quiet shadow.

Light has the power to reveal shape and color, as well as to erase them, and Rodón used it here in both ways. Light describes perfectly Inés's form and colors, as well as a single heart-shaped leaf. As for the remaining plants, most of their outlines have been lost and their colors bleached by the brilliant light, with the shadows also working to hide precise lines and colors.

Besides painting a personal portrait of his niece, Francisco Rodón has described the intense sunlight and shadow of Puerto Rico and the vitality of its plants.

- **Coyote.** *Rufino Tamayo (born Mexico, 1899). Color lithograph, undated.*

Rufino Tamayo described a night full of mystery and fear. The howling coyote stares into space and a strange yellow moon fails to light the gloomy sky. Mountains and tree in the background are dim silhouettes.

You would expect the coyote to be in silhouette, too; but Tamayo took liberties with the direction of the moon's *light*, making it appear to come from the front side of the animal, as well as from behind the mountains.

33

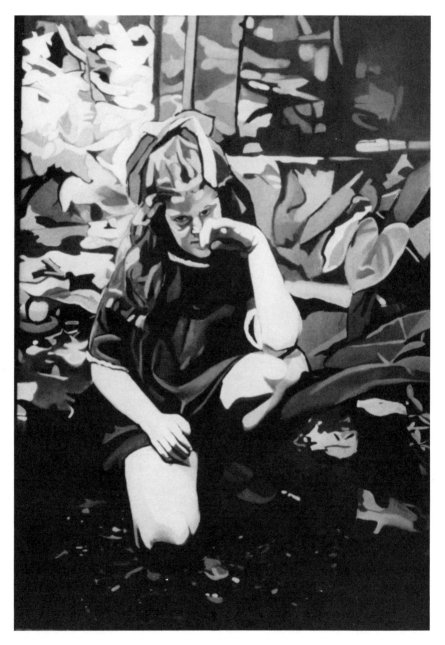

Francisco Rodón. *Watchful Image–Inés II. (Estampa vigilante–Inés II).* Oil on canvas, 1970. 7′ × 4′9″. Collection of Dr. & Mrs. Arsenio Comas-Urrutia, Hato Rey, Puerto Rico. (Photo courtesy of the artist.)

In this way he could show the tension of the coyote's body, the texture of its coat and its wavy stripes of black and red-orange. Bits of light reflect from the legs and ears, around the mouth and exposed teeth; a thin streak of light separates its back from the sky and accents the curve of its back and the curves of the mountains seen below its belly.

Tamayo gave the coyote the shape of the Colima pottery dogs created centuries ago by the Indians of Western Mexico. The prominent moon and sky are reminders, too, of the importance of astronomy to the ancient Indians. Although Rufino Tamayo is a modern artist, he likes to express kinship to his ancestors in this way.

• **Funeral on the Pampas.** *Pedro Figari (born Uruguay, 1861; died 1938). Oil on carton, undated.*

Supernatural *light* floods the huge blue sky. An orbiting moon seems to be lighting a path to heaven for the occupant of the horse-drawn hearse. The trudging figures on foot are bent with sorrow.

More than three-fourths of this painting is sky. Its radiant light resembles the flickering of candlelight during a church service, and gives the picture its religious mood. The artist continued the solemn atmosphere by painting most of the people and horses in tones of gray and by curving the lines of their backs to echo the slow turning of the carriage wheels.

At the same time, Pedro Figari presented us with a glimpse of Uruguay's flat, rolling grasslands, known as *pampas*.

• **Intimacy.** *Emilio Pettoruti (born Argentina, 1892; died 1971). Oil on canvas, 1934.*

Intense sunlight enters a dark room through the open shutters of a window. The artist gave the shaft of *light* a solid shape, to match the overlapping cubist forms of the table, the cloth, and the other geometric objects on and around the table.

In creating light patterns for this cubist still life, Pettoruti was imaginative and realistic at the same time. Parts of the table, and the open shutters, reflect light where you would expect to see it. In other places, Pettoruti allowed his imagination to take over. He "froze" the light at the

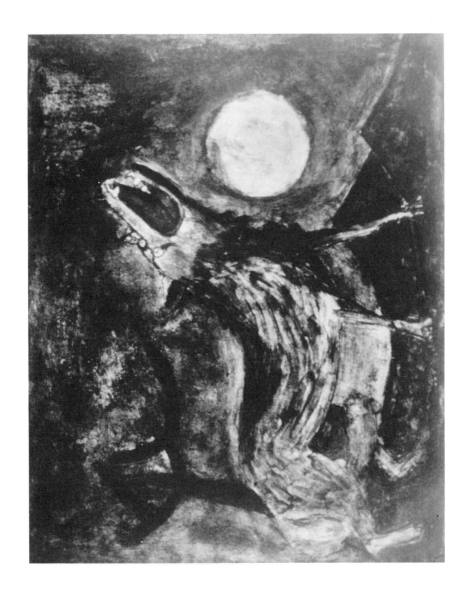

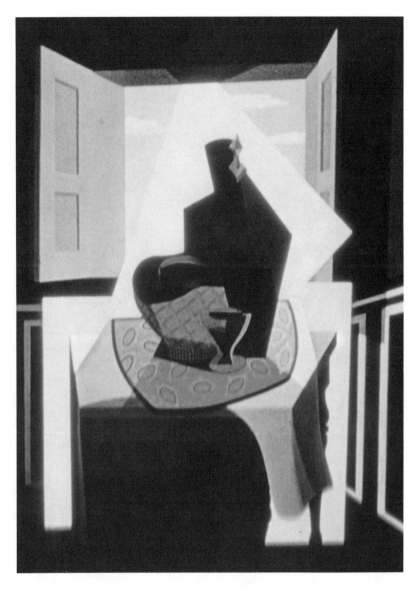

Above: Emilio Pettoruti. *Intimacy.* Oil on canvas, 1934. Private collection. (Photo courtesy of Audio-Visual Unit, the Museum of Modern Art of Latin America.)

Opposite: Rufino Tamayo. *Coyote.* Color lithograph, undated. Courtesy of the Art Institute of Chicago. Gift of Print and Drawing Club. (Photo by Seymour Chaplik.)

window, and introduced an unexpected ray of light coming from somewhere unseen at the front of the picture. It shines on the edge of the goblet and reveals interesting patterns, shadows and shapes, including a large rectangle of white in back of the table.

Playing with light and shadow, Emilio Pettoruti gave us an intimate glimpse into the corner of a private room.

- **Pedregal.*** *David Alfaro Siqueiros (born Mexico, 1896; died 1974). Oil and acrylic on masonite, 1954.*

Light from a blazing fire glares from the center of an erupting volcano. Lava gushes out, forcing deep furrows into the mountaintop, and bits of shattered rock, earth and lava are strewn about. In one furious moment, nature is both terrifying and beautiful.

Pedregal was once the site of an active volcano. In ancient times it discharged its molten lava onto the slopes of the Valley of Mexico.

When Siqueiros painted his own portrait (see *The Great Colonel*, page 25), you were reminded of the power of a volcano. In *Pedregal*, the volcanic mountain twists with an almost human movement. The artist's bold brush strokes and the way he painted light and shadow give the picture its powerful movement.

Notice how the fire throws out a bright glow. Just below the fire, the deepest parts of the furrows are filled with shadow, while the raised portions catch the light. A pattern takes shape: in and out, shadow and light. As in a dangerous game of tag, your eye follows the pattern, and the picture is set into motion.

Opposite: Pedro Figari. *Funeral on the Pampas.* Oil on carton, undated. Private collection. Reproduced courtesy of M. Knoedler & Co., Inc. (Photo courtesy of M. Knoedler & Co., Inc.)

*See color insert.

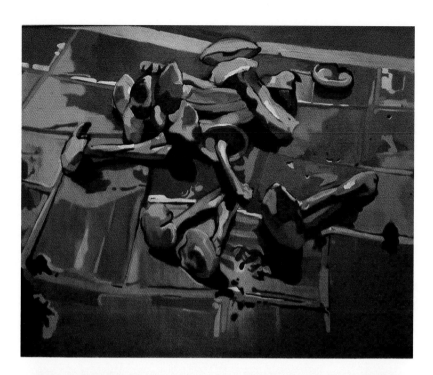

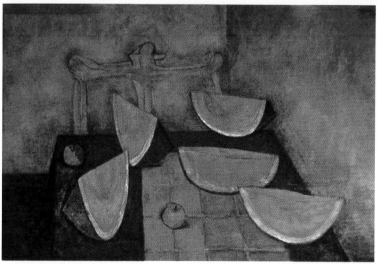

Top: Francisco Rodón. *Wild Mushrooms (Hongos silvestres).* Oil on canvas, 5'4" × 4'5", 1970–75. Collection of Dr. and Mrs. Walter Kleis, Santurce, Puerto Rico. (Photo courtesy of the artist.) *Bottom:* Rufino Tamayo. *Watermelon (Sandías).* Oil on canvas, 1951. Private collection. (Photo courtesy of Audio-Visual Unit, the Museum of Modern Art of Latin America.)

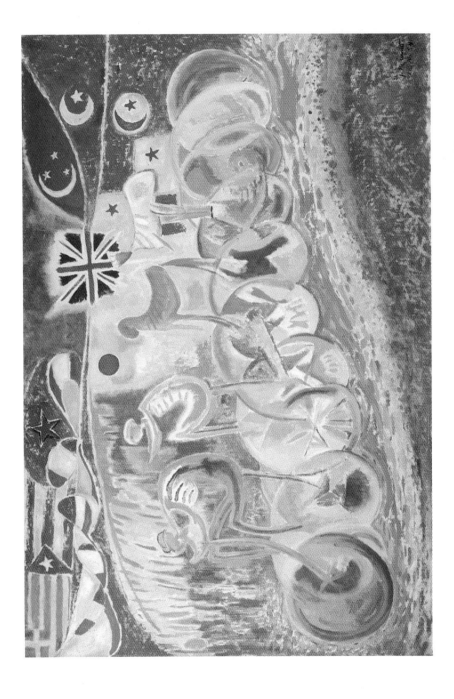

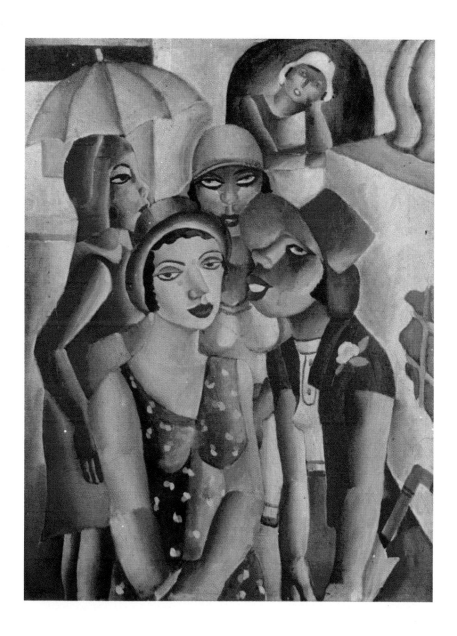

Above: Emiliano Di Cavalcanti. *Five Girls of Guaratinguetá.* Oil on canvas, 92×70 cm, 1930. Courtesy of Museu de Arte de São Paulo, Brazil. *Opposite:* Juan Soriano. *The Bicycle Circuit at France (La vuelta a Francia).* Oil on canvas, 1954. Collection of Instituto Nacional de Bellas Artes y Literatura. Courtesy of Museo de Arte Moderno de Mexico. (Photo by Paulina Lavista.)

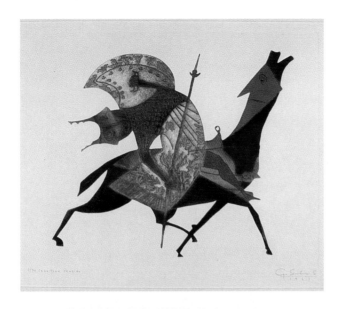

This page, top: Guillermo Silva Santamaría. *Fallen Knight (Caballero vencido)*. In-
taglio print, hand colored, 1961. Courtesy of Phillip Freed, Freed Gallery, Chicago,
Ill. (Photo by Seymour Chaplik.) *Above*: David Alfaro Siqueiros. *Pedregal*. Oil and
acrylic on masonite, 39½"×48", 1954. Collection of Mr. and Mrs. Vernon M.
Wagner, Glencoe, Ill. (Photo by Seymour Chaplik.) *Opposite*: Angel Hurtado.
Triptych (Mars-Venus-Mercury). Collage, 1971. Collection of Ambassador and Mrs.
Gonzalo García Bustillos, Washington, D.C. (Photo by Angel Hurtado.)

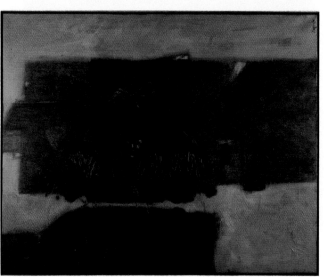

Above, left: Fernando de Szyszlo. *Huanacaúri.* Oil on canvas, undated. The Esso Collection, Lowe Art Museum, University of Miami, Coral Gables, Fla. (Photo courtesy of Lowe Art Museum.) *Right:* Amelia Peláez. *Pacific Sea Flowers (Marpacífico).* Oil, 1943. Gift of IBM. Collection of the Museum of Modern Art of Latin America, Organization of American States, Washington, D.C. (Photo by Angel Hurtado.) *Opposite:* Cundo Bermúdez. *After the Act.* Oil on canvas, 30½″ × 41″, 1961. Collection of Ambassador and Mrs. William Bowdler, Washington, D.C. (Photo by Angel Hurtado.)

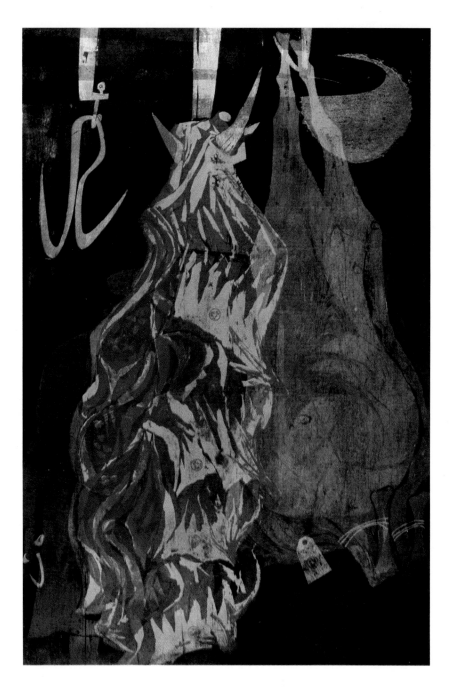

Antonio Frasconi. *14th Street Meat Market*. Woodcut printed in color, 1957. Courtesy of the Art Institute of Chicago. Gift of Mrs. Wallace Landau. (Photo by Seymour Chaplik.)

5. ———————————— Color

- **Wild Mushrooms (Hongos silvestres).*** *Francisco Rodón (born Puerto Rico, 1934). Oil on canvas, 1970–75.*

Freshly picked mushrooms are the subject of a sunny still life. With their long stems and umbrella caps, the mushrooms have absorbed glowing sunlight. Bits of black earth in the painting are reminders of Puerto Rico's rich but scarce soil.

Francisco Rodón used black and white and a variety of *colors* to reflect the intense sunlight and shadow of Puerto Rico. White highlights in the background and black bits of earth represent the two opposite poles of light and dark. By mixing red, yellow and blue, the primary colors, the artist produced shades of orange, green, purple and brown in various degrees of lightness and darkness.

Rodón knew that the reddish browns and bluish browns he used for background and for shadow would go well with the yellow and yellow-orange of the mushrooms. The warm yellow and the red tones are balanced by the cool effect of the blue lines and the bluish-brown areas.

After picking mushrooms in the mountains of Barranquitas, Rodón wrapped them in newspaper to keep them fresh for three days, long enough to capture their color on canvas. The way he painted the newspaper as background is a good illustration of abstraction. Instead of copying the fine newsprint, he marked the paper into squares and rectangles, the way columns of print and advertisements divide a newspaper page. By eliminating the small details, he created an interesting abstract background for the plants, and gave importance to the contrasting colors of sunlight and shadow.

*All works discussed in this chapter are in the preceding color insert.

• **Watermelon (Sandías).** *Rufino Tamayo (born Mexico, 1899). Oil on canvas, 1951.*

In the corner of a room, five half-moon slices of watermelon stand invitingly on a table. The top edge of a graceful chair repeats the curved lines of the melons. In contrast to the curves are the straight edge of the table and the squared-off mat in the center. Rosy red *color* floods the room, touching every object; and from somewhere unseen, a soft light illuminates the corner and casts violet-colored shadows.

The key to understanding this painting is in its color. Since red is associated with fire in the natural world, it is seen in the art world as a warm color. By adding red paint to every tone he mixed, Rufino Tamayo helped spread the warm, rosy glow. The color is not only a reminder of Mexico's semitropical climate, but it describes the artist's native country in other ways. For instance, many Mexican homes, inside and out, are painted this shade, and the same color is found frequently in folk art made by the people.

Tamayo showed another aspect of Mexico in the rough texture of the walls, reminiscent of so many of the country's old stone and adobe buildings. And the ripe watermelon brings to mind all the other beautiful fruits grown in Mexico and sold from colorful heaps in the marketplaces.

• **Bicycle Circuit at France (La vuelta a Francia).** *Juan Soriano (born Mexico, 1920). Oil on canvas, 1954.*

Wheels are whirling and flags are flying as fantastic creatures speed around a curving bicycle track. Stars and stripes and crescent moons are scattered among the banners for an international race in France. Contrasting *colors* and the artist's quick brush strokes increase the air of excitement and tension. For a moment you can almost imagine yourself a spectator at the race.

Juan Soriano placed patches of stirring purples, greens and oranges alongside one another to imitate the nervous, racy atmosphere. In many places the artist applied his colors to the canvas with small, swift brush strokes to emphasize the swiftness of the race. Next to each other, the small dabs of color set off a vibration that affects first the eye of the observer and then the emotions.

Lines and colors work together to heighten motion as well as emotion. Winding lines of color that mark the bicycle path, plus the rolling circles of multi-colored wheels, add to the lively movement of the picture.

- **Five Girls of Guaratinguetá.** *Emiliano Di Cavalcanti (born Brazil, 1897; died 1976). Oil on canvas, 1930.*

Color and light work together in Cavalcanti's painting to display the happy side of Brazilian life. The country's sparkling sunlight illuminates the beautiful skin tones of the girls. It shows off their perky hats and the vivid colors of their clothing. Bright light bounces off the smooth-textured walls of the surrounding buildings, while shadows are filled with warm dark reds and purples. Carefree pleasure, jauntiness and good times are reflected everywhere.

The artist gave unity to the vivid blues, pinks and reds with an even distribution of light. He matched the lively colors with spirited movement produced by the swinging arcs of the umbrella, the rounded hats, and other curving lines and shapes.

- **Triptych (Mars-Venus-Mercury).** *Angel Hurtado (born Venezuela, 1927). Collage, 1971.*

Each panel of this triple painting shows a separate spatial landscape. Together they form a single poetic view of outer space. The luminous *colors* and slow movement of the planets invite you to dream of other worlds – life on Mars? Interplanetary wandering? Or, perhaps, a dream of private worlds from the magic space of your own mind.

Color, space and movement are connected in this painting. The artist, Angel Hurtado, knew that warm colors appear to come forward in a pic-ture, while cool colors appear to withdraw to the background. At the same time, dark and shadowy forms draw back, while light areas come forward.

What happens, therefore, in the center panel is that the warm, red Venus and the cool but light-colored disk both seem to belong in the for-ward space. They appear to move back and forth in the atmosphere as your eye tries to set them in separate places. This adds to the feeling of floating movement and endless space.

The fine lines and ridges in the picture suggest clouds of vapor, canals and mountains. To create these effects, Hurtado used layers of transparent paper, both colored and white. After cutting them to shape and pasting them onto the canvas, he covered them with acrylic paint and a coat of varnish to protect their color.

6. ———————— Texture

• **Untitled Painting.** *Alejandro Arostegui (born Nicaragua, 1935). Mixed media, 1964.*

How small man is compared to nature. Mountains, land and sea are so vast, they dwarf the men standing on the hilltop. Even the birds in the foreground, because they are closer to you, appear larger than the men. Still, Alejandro Arostegui seems to be saying that men are powerful enough to change the surface of the earth.

From this painting and from other works by the artist, it is clear that he is painfully aware of the accumulation of debris and pollution brought about by modern man. His own city, Managua, suffers no less than other cities of the world from problems of pollution.

Arostegui expresses his concern by covering two-thirds of this painting's surface with a gritty *texture* that suggests the rubble and remnants of living. He achieved this texture by adding clay and bits of bones, stones and shells to the paint he used. On the original painting, the rough surface texture can be felt with the hand as well as seen by the eye.

Those who know Nicaragua recognize the jutting shape of its coastline in this painting. The artist emphasized the pollution problem by saturating the entire scene with the same muddy green color.

• **Astrofish.** *Raquel Forner (born Argentina, 1902). Oil on canvas, 1961.*

In her way, Raquel Forner may have been the first woman to explore space. Through her imagination, she has spent as many years as our actual astronauts investigating the atmosphere, and in this painting, she presents

45

Above: Raquel Forner. *Astrofish.* Oil on canvas, 1961. Collection of Maestro and Mrs. Guillermo Espinosa, Washington, D.C. (Photo by Angel Hurtado.)

Opposite: Alejandro Arostegui. *Untitled.* Mixed media, 1964. Collection of Ambassador and Mrs. William Bowdler, Washington, D.C. (Photo by Angel Hurtado.)

Lotte Schulz. *Parchment 1 (Pergamino 1)*. Dye on leather, 1964. The Esso Collection. Courtesy of Lowe Art Museum, University of Miami, Coral Gables, Fla. (Photo courtesy of Lowe Art Museum.)

her vision of a creature who might be met on a future trip through outer space. Before recognizing the outline and backbone of this flat, upright fish, you can see traces of thick, *textured* paint applied in uneven patches and strong black lines.

Unlike Alejandro Arostegui, who adds unexpected materials to his paint, Raquel Forner creates a heavy texture with clots of pure paint. In the art style known as abstract expressionism, she has spilled a great deal of emotion onto the canvas.

Forner's paintbrush is an extension of her fingers, and she has expressed her feelings through quick brush strokes and rough textures of paint. You can see the traces of pressure she used to make the heavy black outline of the fish's body, near its right fin. Starting with a thick, rich black, her strong brush stroke ended with most of the paint gone. Continuing to drag the brush, almost dry, she left a pebbly trail of textured black paint.

The excitement and fear astronauts experience as they explore space may be part of what Raquel Forner wanted to express.

• **Parchment 1 (Pergamino 1).** *Lotte Schulz (born Paraguay, 1925). Dye on leather, 1964.*

Seen through a high, arched doorway, a *textured* moon peers from a hazy red sky. Geometric lines and shapes describe a bit of Spanish architecture. Working on leather, an abundant material in her country, Lotte Schulz added texture to texture, creating rich surfaces to examine—floors, walls, moon and sky.

Note the variety of patterns she created with the assorted textures. Fine lines going up and down form the base of the building, while shorter, horizontal lines, crowded together, represent the floor on one side of the doorway; on the other side, a tiny wedge of spotty shapes marks the floor. The doorway wall seems made of irregular stones, darker and larger than those seen through the doorway. The moon reflects the same smaller texture, while the sky is made of large and loose shapes, suggesting soft, floating textures.

The orderly patterns of the textures bring a quiet quality to the painting. Seeking to please the eye, Lotte Schulz did not express the strong emotions called up by the harsh textures in the works by Raquel Forner and Alejandro Arostegui.

Antonio Berni. *Ramona in the Show*. Relief intaglio, 1965. Courtesy of the Art In-
stitute of Chicago. Gift of Print and Drawing Club. (Photo by Seymour Chaplik.)

• **Ramona in the Show.** *Antonio Berni (born Argentina, 1905). Relief intaglio, 1965.*

This dazzling creature is Ramona Montiel, a make-believe character and the heroine in a series of pictures created by Antonio Berni to tell a true-to-life story. At the beginning of the series Ramona is a poor girl from the shanty towns of Buenos Aires. Through no fault of her own, she falls into unfortunate habits, and others use her badly. Telling her story through pictures, the artist has her traveling around the world, meeting with many people and experiences. Through the influence of friends and protectors, she changes from a shady lady to a virtuous woman.

Berni shows Ramona here before her change. Printed in bold black and white, she is nearly life-sized in the original print, and her jazzy cabaret-girl costume provides a good illustration for *texture*, as well as pattern. The white portions are pressed out in relief, giving the surface a three-dimensional quality. Where the arms and shoulders are raised away from the black background, the texture is smooth. In all other places, the pressed-out white areas are tiny and produce a pebbly texture that can be felt with the hand as well as seen by the eye.

Berni created interesting surfaces by using patterns made of small shapes, repeated at regular intervals against a contrasting background. These are prominent on Ramona's stockings and the veil in her hair. The patterns are larger and more elaborate in the body suit and jewelry, but all are carefully balanced and contribute to the intricate texture of the print.

7. —————— Pattern

• **Daughter of the Dancers.** *Manuel Álvarez Bravo (born Mexico, 1907). Photograph, 1932.*

By now you understand that *pattern* refers to the order in which basic elements are seen and repeated.

The wall of an old building in Mexico provided a ready-made pattern for the background of this picture. When a young girl peered into the circular window, Manuel Álvarez Bravo was there with his camera to record the simple beauty of the moment. With the keen eye of the artist, he could appreciate the appearance of pattern on pattern.

At a glance the photographer could see that the girl's head and hat repeated the round shapes of the window and its frame. Instead of being completely surrounded by space, each circle sits within, or overlaps, another circle. This pattern of circles is a contrast to the evenly spaced rectangles and diamond shapes of the brick wall.

Going beyond the variety of shapes, you can enjoy the photograph for its patterns of light against dark, or for the patterns made by the powdery texture of the crumbling bricks.

• **14th Street Meat Market.*** *Antonio Frasconi (born Argentina, 1919). Woodcut printed in color, 1957.*

Not many of us would find inspiration for a work of art in a meat storage locker. But Antonio Frasconi's love for working people and everyday life takes him to unexpected places. In this picture Frasconi

*See color insert.

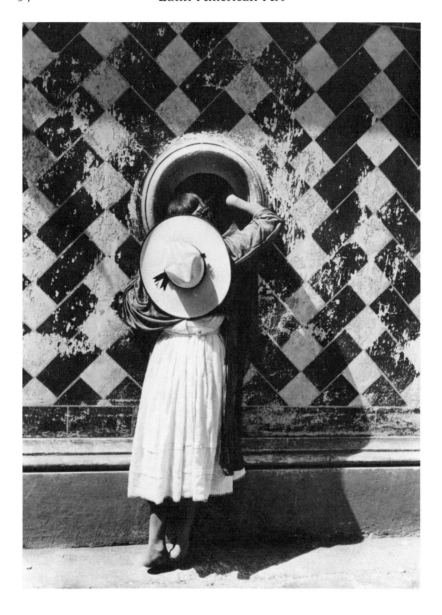

Manuel Álvarez Bravo. *Daughter of the Dancers.* Photograph, 1932. Collection of Instituto Nacional de Belles Artes y Literatura, Mexico, D.F. (Photo courtesy of the Art Institute of Chicago.)

emphasized shapes and shadows to bring out the natural *patterns* he saw in the meat market.

Two shapes of beef hang from gleaming steel hooks. One carcass is skinned and exposes a twisting surface of soft, red meat and hard, tan-colored fat. Notice how Frasconi made the jagged shadows on the fat. They are dark, angled "V"-shaped lines that resemble the shape of the steel hooks. The regular intervals of space between the shadows produce a lively pattern.

Another pattern lies in the order of the hooks suspended from the ceiling. Starting on the left, the hooks ascend, as if they were stairs going up. Below them, the two carcasses hang in the same ascending order. And the shadowy outline of a butcher near the left edge of the picture becomes the first of three shapes that move upwards, repeating the pattern of the hooks.

Frasconi printed his picture on paper with carved blocks of wood. He used simple cutting tools to carve separate blocks for each color. The surfaces of each block were inked and printed separately, one on top of the other, to produce the finished picture.

- **After the Act.*** *Cundo Bermúdez (born Cuba, 1914). Oil on canvas, 1961.*

A troupe of performers strikes a thoughtful pose. Are they dancers? Acrobats? Pantomime artists? Though they are sad-eyed and mouthless, their group portrait produces many playful *patterns*. Cundo Bermúdez followed an old tradition in showing the underlying sadness of a group of clownlike players.

In looking for patterns, consider first how the painter distributed colors. Each performer wears at least a touch of green and black, and most wear harmonizing shades of red (from orange to brown). Clothes are divided into colored segments, and each related color becomes part of a flat pattern seen against the brilliant blue background. The blue unifies the color schemes and emphasizes the unity of the troupe.

The colorless faces and bare arms form patterns of duplicate shapes,

*See color insert.

while the position of legs, elbows and knees forms another. Even the fanciful hats fall into a pattern of their own.

To those who know Cuba, there is special meaning in the colors and patterns of this painting by Cundo Bermúdez. Cuba's tropical sunlight gives its flowers and fruits the same rich coloring. And the artist's two-dimensional color patterns divided by black lines could have been inspired by the stained glass windows of Cuba's old Spanish architecture.

• The Presidential Family. *Fernando Botero (born Colombia, 1932). Oil on canvas, 1967.*

The mountain setting suggests this is the portrait of a South American president and his extended family. Perhaps he is from the artist's own country, Colombia, since Botero included a humorous portrait of himself working at an oversized easel. Carefully drawn, this dignified gathering of plump people seems sad and funny at the same time.

Side by side, the mountains at the top of the painting become a *pattern* that is repeated in the arrangement of the people. Think of the president's derby and the military man's cap as representing two mountain tops, and the people on either side of them as representing the direction of the mountain slopes. If you begin with the seated woman on the left and follow the outline of necks and heads, you will find your glance moving up and down and across the painting, imitating the pattern of the mountains.

When Botero perched his presidential family on dangerous footing among Andean mountain peaks, was he making a subtle political statement?

• Interfering Parallels Black and White (Paralelas interferentes negras y blancas). *Jesús-Rafael Soto (born Venezuela, 1923). Plaka and wood, 1951–52.*

The *patterns* in Soto's optical work are subtle and complex. There is no one center of interest in this work. A series of black and white bars move across the painting in a diagonal direction. Only one strip proceeds from side to side without interruption. Interfering with the other diagonals are sets of parallel lines and shapes that set up dizzying vibrations. Forms

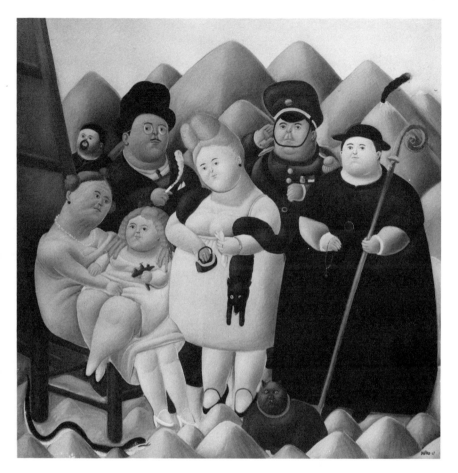

Fernando Botero. *The Presidential Family*. Oil on canvas, 6'8⅛″ × 6'5¼″, 1967. Collection, the Museum of Modern Art, New York. Gift of Warren D. Benedek.

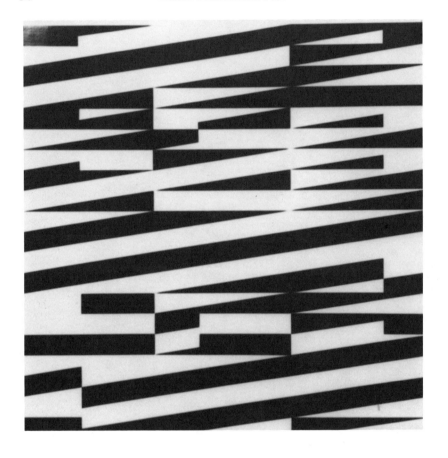

Jesús-Rafael Soto. *Interfering Parallels Black and White (Paralelas interferentes negras y blancas)*. Plaka and wood, 1951–52. Collection of Museo de Arte Moderno "Jesús Soto," Ciudad Bolívar, Venezuela.

collide with one another and create new forms and spaces. It is hard for the eye to linger anywhere. The repetition of interfering parallels becomes the major pattern.

Movement in art implies a passage of time—the time it takes for the eye to absorb what is happening as it moves from one element to another.

Soto feels the movement within his art is related to the movement of human beings within the universe. As he experiments with patterns of movement and changing shapes, Soto hopes to increase understanding (his own, as well as the spectator's) of the complex relationships between motion, time and space in the real world.

8. ——————— Rhythm

- **Warrior.** *Marcelo Grassmann (born Brazil, 1925). Ink drawing, 1958.*

Such a fantastic knight probably never set out for war or tournament. Dressed in armor that leaves his hands and feet bare, this warrior carries two weapons. One is the double dagger-blade of a nose, which also projects from the back of his helmet. The other is a grinning, two-footed fish held under his arm, as threatening as any sword. Man and monster seem a heavy load for the small horse, whose ferocious expression, however, is equal to theirs. The kinship of the trio contains the *rhythm* of this drawing.

Rhythm in art is a part of every pattern, but it has its own identity. When an artist repeats any element, your eye muscles must move to see the repetition. This movement is the core of rhythm.

In Grassmann's drawing, the strongest rhythm is in the relationship of the three heads: man, horse and fish. The heads are not identical in shape, but each is somewhat oval, has a pointed nose and faces the same direction.

Rhythm in art is not unlike rhythm in music. If you can imagine the sound of a drumbeat as your glance moves from one head to another, there is a parallel in the silence between the booms of the drum and the spaces between the heads.

With the rhythmic lines of his pen and a rich imagination, Marcelo Grassmann brought to life a personal fantasy.

- **Chiron.** *Augusto Marín (born Puerto Rico, 1921). Acrylic on cardboard, reinforced with masonite, 1967.*

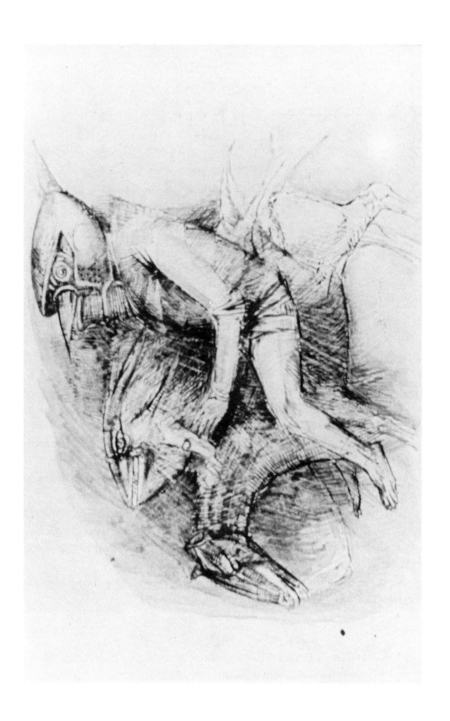

Above: Augusto Marín. *Chiron.* Acrylic on cardboard, reinforced with masonite, 1967. Collection of Mr. and Mrs. Max Goldman, San Juan, Puerto Rico. (Photo by Roso Sabalones.)

Opposite: Marcelo Grassmann. *Warrior.* Ink drawing, 1958. Collection of the Museum of Modern Art of Latin America, Organization of American States, Washington, D.C. (Photo by Angel Hurtado.)

How different are Marcelo Grassmann's fierce *Warrior* and Augusto Marín's peaceful *Chiron*. For his painting, Marín borrowed an idea from an ancient Greek story. Throughout the centuries artists have invented images of Chiron according to their personal visions. A creature who was half horse and half man, Chiron was not savage, as the other centaurs of the story, but a wise physician and a friend to humans.

The bold *rhythm* of Grassmann's picture would not be appropriate for *Chiron*. Here instead is a flowing rhythm in the outline of the horse's shape. Study the curves made by the horse's head and neck, his back and legs, the arch made by the space between his legs and the underpart of his belly. The curves resemble each other. They are not separated by empty space, but flow smoothly in a continuous line. This rhythm can be compared, not to the beat of a drum, but to a lyrical melody played on a violin.

There is another rhythm, of the drumbeat variety, in the disconnected patches of light that flicker across the horse's body. Seen against the dark background, the effect is similar to the intense sunlight and shadow you find in Puerto Rico, Marín's native island.

• **Mayan Motif No. 1.** *Carlos Mérida (born Guatemala, 1891; died 1984). Gouache, 1932.*

For his *rhythmic* painting, Carlos Mérida used themes from the ancient Maya who lived in the Guatemala-Mexico area. The large shapes are joined at their sides, as if they were Siamese triplets. Alone, each figure resembles the stone sculpture created by the early Maya; connected, they resemble Mayan glyphs (picture writing). The smaller shell creatures would have been symbols to the Maya (as they are to people today) of the life cycle of all creatures.

Understanding their connection to Mayan times is not necessary to appreciate the simple rhythms of these forms. The large triplets, with their heavy outlines, can be compared to three long notes of music, with barely a pause between them—perhaps as heard in the sounds of a horn. The tempo of the painting changes, and the rhythm becomes disconnected and soft, as one's eye moves along the three separate, small shells, followed by a long pause and two tiny shells, all creeping in slow measure around the larger shapes.

Carlos Mérida. *Mayan Motif No. 1.* Gouache, 1932. Collection of the Art Institute of Chicago. Gift of Earle Ludgin. (Photo by Seymour Chaplik.)

Rhythms appreciated through your ears at a concert can be enjoyed through your eyes in viewing a painting.

• **Pacific Sea Flowers (Marpacífico).*** *Amelia Peláez (born Cuba, 1897; died 1968). Oil, 1943.*

Resembling a stained glass window, this still life sparkles with light, color and design. A light-filled blue is the dominant color, representing the waters surrounding the island of Cuba, the artist's native land.

Central to the painting's *rhythm* are the flowing forms of the orange and white flowers rising above the patterned vase. But other rhythms move across the painting.

The dips and twists of all the fast-moving lines wander and criss-cross, producing an assortment of patterns and rhythms of quick tempo. The small designs decorating the vase and other parts of the painting are made of small shapes repeated closely, one after another. The smaller the space interval between the shapes, the faster the rhythm seems to go.

Inspired by the flowers, colors and designs of her home and garden, Amelia Peláez has shown us a bit of Cuba: Many old Spanish homes in her native country have colorful stained glass windows and are decorated with black iron gratings bent into designs similar to those in her painting. She also mirrored Cuba's clear sunlight, its brilliant tropical plants and the quality of the surrounding sea in the light-filled colors of her canvas.

• **Shells.** *Julio Rosado del Valle (born Puerto Rico, 1922). Mural executed in oil and collage, 1971–74.*

In this painting of shells, Julio Rosado reminds us that the *rhythms*, shapes and colors of the natural world are what we find satisfying to look at in the world of art.

The greens Rosado used in the background are the colors he often sees

Opposite: Julio Rosado del Valle. *Shells.* Mural executed in oil and collage, 1971–74. Collection of University of Puerto Rico, Río Piedras, Puerto Rico. (Photo courtesy of the artist.)

*See color insert.

in the waters surrounding the island of Puerto Rico. He borrowed the other colors from nature, too, and picked up models for the shells along Puerto Rico's beaches.

In the dry, white portions of the shells you can almost feel the island's hot sun scorching the sands. The flowing lines of the shells and their bands of color repeat the endless waves of the ocean. They provide a picture of quiet rhythms and slow tempo.

Aside from the calm, flowing rhythms within each shell, the artist's arrangement of the shells creates another rhythm. In organizing the composition, Rosado placed the large shells in an upside-down "V" formation. The three smaller shells have the same formation, but the "V" shape is right side up. Dark areas between the shells provide a feeling of space and silence, slowing down the tempo of the drumbeat rhythm.

9. ——— Contrast

• **Birth (Nacimiento en Cordell).** *Mauricio Lasansky (born Argentina, 1914). Intaglio print, undated.*

A tender scene is enacted here as a group of people cluster around the bed to see a new baby. Eyes closed, the tiny newborn is nestled near its mother. A small child has crawled onto the bed for a better look. Others gaze in wide-eyed wonder.

Mauricio Lasansky used dramatic *contrasts* of bright light and dark shadow to record this happy moment. While the background is a deep, inky brown, the two standing figures on the right edge of the group are printed in a middle tone of darkness. In sharp contrast, another part of the picture is flooded with light.

In the light-flooded section, a grandmotherly woman on the left bends forward. The contrasting light and the lines of her figure lead our eyes downward, past the proud father, to the mother and infant who are, after all, the most important people in the picture.

• **The Flag (La bandera).** *José Clemente Orozco (born Mexico, 1883; died 1949). Lithograph, undated.*

The curved backs of the men in sombreros suggest they are burdened with heavy weight. A large Mexican flag, bayonets, and the sad figure of an expectant mother make us aware the men are carrying the body of a victim of war.

To express grief and disaster, Orozco chose stark *contrasts* of light and dark, but he used them differently than Lasansky did for *Birth*. The tri-striped Mexican flag is a mass of darkness against a white background. Drawn with a few sketchy lines, the woman is mostly in white — a

69

Mauricio Lasansky. *Birth (Nacimiento en Cordell)*. Intaglio print, undated. Courtesy of the Art Institute of Chicago. William McCallin McKee Collection. (Photo by Seymour Chaplik.)

José Clemente Orozco. The Flag (*La bandera*). Lithograph, undated. Courtesy of the Art Institute of Chicago.

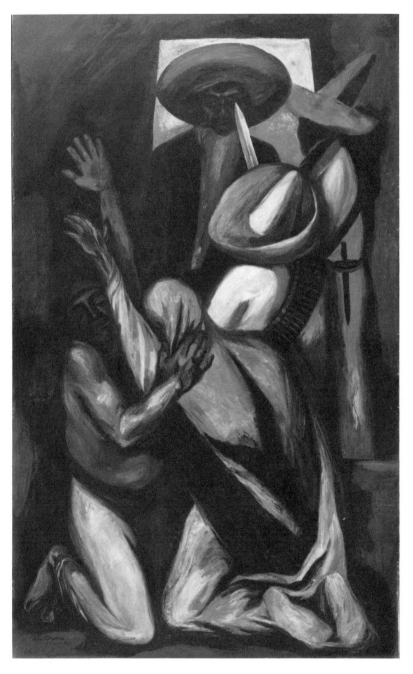

José Clemente Orozco. *Zapata*. Oil on canvas, 198.8×122.2 cm, 1930. Courtesy of the Art Institute of Chicago. The Joseph Winterbotham Collection. Copyright 1987 the Art Institute of Chicago. All Rights Reserved.

dramatic contrast to the dark flag and the dark shadowy depths of the picture.

The diagonal direction of the flagpole is repeated by the two black bayonets slashing across the white background like zinging bullets. They direct our attention to the gray and black areas at the left, where the eerie shapes of a platform and hook heighten the sense of tragedy.

The severe rectangular shapes in the background and in the flag lend themselves to the tragic mood. Their straight, sharp edges are a contrast to the curves in the hats and bodies of the mourning figures.

Although José Clemente Orozco created this picture during Mexico's Revolution, it can have meaning to people everywhere who know the sorrow of war.

• **Zapata.** *José Clemente Orozco (born Mexico, 1883; died 1949). Oil on canvas, 198.8×122.2 cm, 1930.*

Using a different medium, Orozco created another picture of *contrasts.* Zapata, one of the heroes of the Mexican Revolution, is shown inside an adobe, with two soldiers and the kneeling figures of two peasants. Tragic and noble, they represent the contrasting emotions of despair and hope filling the hearts of the revolutionaries of their time.

In the original painting, the red-brown adobe walls are a rich contrast in color and texture to the blue-white sky showing through the open doorway. Zapata's dark figure, painted with curved outlines, is a contrast in color and line to the straight edges of the doorway and the light sky.

The strong colors the artist used for the adobe walls and for Zapata and the kneeling peasant are a contrast to the delicate tones of rose, gray and white in the light clothing. Orozco sharpened the contrast by deepening the shadow on the wall behind the kneeling figure and the outstretched arms.

• **Teaching of the Indians.** *Candido Portinari (born Brazil, 1903; died 1962). Dry plaster in tempera, 1941.*

Part of Brazil's history is illustrated in this painting. It also describes the missionary work going on in all the Latin American countries after the

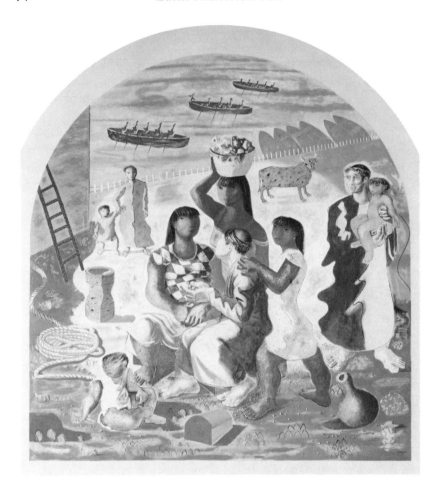

Candido Portinari. *Teaching of the Indians*. Dry plaster in tempera, 1941. Mural at the Hispanic Foundation, Library of Congress, Washington, D.C.

sixteenth century conquest; and the painting's coastline setting is a reminder that European settlers arrived by boat.

Portinari emphasized the *contrast* of land and sea with different colors and textures. In the foreground he used the red-brown earth of Brazil's coffee plantations. Next to it, he showed a large patch of land bleached almost white by the blazing sun. Beyond are the wavy blue waters of the sea.

Examine the loose robes of the missionaries and see how the artist divided them into contrasting sections of light and shadow. The missionary on the right, holding an Indian child, wears a garment with a particularly bold dark and light pattern; and the artist further called attention to this man by giving more details to his face, in contrast to the sketchiness of other faces.

Brazilian folk objects in the painting stand out against the rich earth because of their contrasting textures. Study the surface of the pottery vase, the shining metal trunk and the coiled rope. The white gourd container balanced on the head of the Indian woman is a contrast in both texture and color to her mahogany hair and skin.

10. —— Balance

- **Last Slave of the Banana Plantation.** *Lasar Segall (Brazilian citizen; born Russia, 1890; died 1957). Oil on canvas, 1925.*

A Brazilian field is thick with banana plants. The huge leaves overlap, cross one another and nod in different directions. From the midst of the leaves rises a single stem bearing a cluster of green bananas. Almost in the same way, the plantation worker's neck and head rise from the bottom edge of the picture.

The artist achieved a *balance* by placing the man along the painting's vertical center line. That (invisible) line divides the picture field into two sections. Similar in size and details, the two sections are close to being identical (symmetrical).

Lasar Segall knew that when a canvas is divided this way, whatever occupies the center space has the force of a magnet. You may wish to examine the rhythmic surface of the leaves: to notice their geometric lines; to ponder their unnatural light; to wonder about their various shades of green. But the face of the plantation worker compels you to return to it because of its central position.

Perhaps the artist chose this simple symmetrical balance to emphasize the human element involved in Brazil's agricultural system. When slavery was abolished in Brazil, the pure African Negro began to disappear, many absorbed into Brazil's population of Indians and Europeans. New immigrants from Europe began to take the place of the Negro in the fields.

Segall's plantation worker seems to combine the features of both the African and European races.

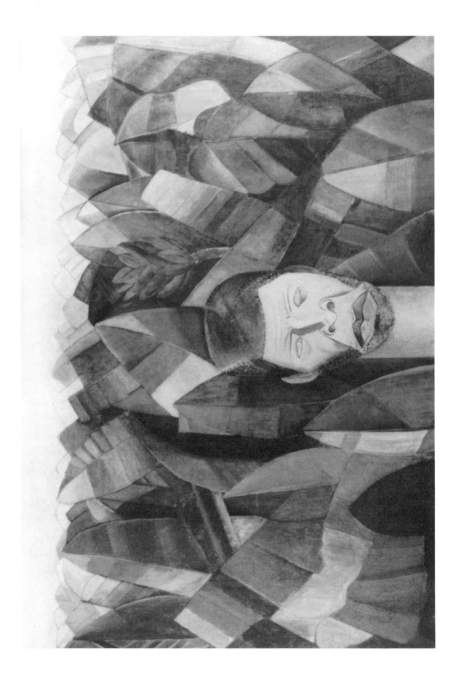

Above: Frida Kahlo. *The Two Fridas (Las dos Fridas).* Oil on canvas, 1938. Courtesy of Museo de Arte Moderno de Mexico. (Photo by Paulina Lavista.)

Opposite: Lasar Segall. *Last Slave of the Banana Plantation.* Oil on canvas, 1925. Courtesy of Pinacoteca do Estado de São Paulo, Brazil. (Photo courtesy of Museu de Arte de São Paulo.)

• The Two Fridas (Las dos Fridas). *Frida Kahlo (born Mexico, 1910; died 1954). Oil on canvas, 1938.*

To express her melancholy feelings, Frida Kahlo painted a surrealistic double portrait of herself. The arrangement gives the picture a quiet *balance*, similar to the painting by Lasar Segall. The clasped hands of the two Fridas occupy the important central position. On either side a grim Frida looks out at you. Almost a mirror image of one another, the two are joined by the arteries of their exposed hearts.

The exact balance of the two figures is not affected by the differences in their clothing or in the objects they hold. Frida Kahlo once explained that on the right is the Frida who was loved by her husband, Diego Rivera. She reveals his importance by showing her life's blood coming from the miniature portrait of her husband in her hand. Attached to the tiny frame is a long artery that winds around her arm, connects to her heart and then carries the supply of blood to the second Frida, the wife Diego no longer loved. The second Frida holds a surgical clamp, with which she can halt the loss of blood.

The balance of the picture extends to the stormy sky. If an imaginary line were drawn down the center, it would divide the sky into two similar portions of cloudy darkness, to match the moods of the melancholy Fridas.

• Hills (Colinas). *María Luisa Pacheco (born Bolivia, 1919; died 1982). Oil and collage, 111.6×137.2 cm, 1980.*

The title of this abstract painting adds meaning to its dramatic *balance* of shapes, colors and textures. Knowing that María Luisa Pacheco's native Bolivia is crossed from border to border with spectacular mountain ranges, you can easily imagine they were the inspiration for *Hills*. Instead of offering an exact representation, the painting suggests a feeling of strength and majesty the artist may have personally carried away from the Bolivian landscape.

Balance in this rugged mountainscape is subtle and asymmetrical; that is, the two sides of the painting are not alike. The icy white peak on the left is leaner than the form on the right, and is surrounded by large areas of clear sky. It is given visual balance by the support of diagonal, pyramid-like shapes that appear riveted to the bottom edge of the canvas. The

María Luisa Pacheco. *Hills (Colinas)*. Oil and collage, 111.6×137.2 cm, 1980. Collection of Julio and Clemencia Pacheco, McLean, Va. (Photo by Félix Angel.)

massive form on the right extends beyond the top of the picture. Its darker tones and the black, jagged, triangular shapes at the base of the painting give it extra weight.

The two center edges of the mountain slopes are diagonal lines that cross near the bottom of the painting, in a central position, connecting the two sides and providing a stable, balanced view.

Colors and textures are as well balanced as shapes. A few rust-colored areas provide a foil for the tones of white to gray to black that make up Pacheco's palette here. Her use of wood, corrugated material and sand gives a variety of textures.

• **Huanacaúri.*** *Fernando de Szyszlo (born Peru, 1925). Oil on canvas, undated.*

Ancient Peruvian history was the inspiration for Fernando de Szyszlo's modern abstract painting. Although there seems to be a mirror image of a dark Indian profile, none of the forms are based on anything specific. They represent the artist's memories and thoughts of the landscape, the stones, and the hills of Cuzco, a place in Peru sacred to his Inca ancestors.

Huanacaúri is a hill named for an ancient Indian emperor. Once the location of noble battles and religious ceremonies, it has been the subject of many legends. In balancing the old with the new, the artist achieved a *balance* of colors and shapes.

The brown vertical panel running through the painting is off-center, extending more to the right than to the left. To keep the picture from being too heavy on the right, the artist added extra weight to the opposite side by including two black, semicircular shapes resembling Indian profiles. The visual weight of the black forms helps to equalize the arrangement, giving it a steady balance.

Aided by tiny splashes of orange light, the dark, warm colors pull away from the cool blue-green background. A smoky quality penetrates all the colors, which are as well balanced as the shapes.

*See color insert.

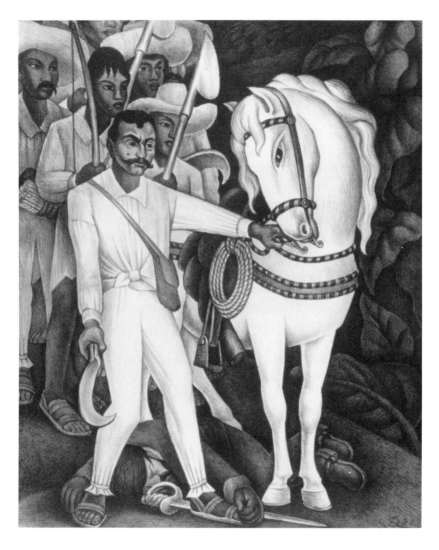

Diego Rivera. *Zapata*. Lithograph, undated. Courtesy of the Art Institute of Chicago.

• **Zapata.** *Diego Rivera (born Mexico, 1886; died 1957). Lithograph, undated.*

The commander of a twentieth century rebel army in Mexico, Zapata, leads the white stallion of Cortés, a sixteenth century Spanish conqueror. With an artist's freedom, Diego Rivera combined two periods in Mexico's history.* Emiliano Zapata stands at the head of a peasant army fighting for land. In his right hand is a scythe, symbol of the people's struggle against tyranny, past and present. The peasants carry farming tools and a simple bow and arrow, but in spite of their primitive weapons, they have felled an enemy soldier, whose sword lies stretched at Zapata's feet.

The *balance* of the picture's weight is divided more or less evenly between the right and left sides. In the exact center of the picture, a coiled rope hangs from the horse's saddle. The weight of the horse on one side is balanced by the total weight of Zapata and his band of fighters. Zapata's outstretched arm leads your gaze from the small group toward the other side of the picture, where the horse's inclined head and the coiled rope hold your attention.

Light and dark areas are well balanced, too. Notice how the brightest light falls on the noble horse and the figure of Zapata, the two leading actors in this drama. Less light falls on the peasants following him, while the background to the right and the body of the dead soldier are almost lost in shadow.

*This lithograph is based on one of the murals Rivera painted on the walls of Cortés Palace in Cuernavaca, Mexico. The murals tell Mexico's history from the Spanish conquest to the early twentieth century revolution.

11. Unity

• **Desperation (Desesperación).** *Oswaldo Guayasamín (born Ecuador, 1919). Oil on canvas, 1947.*

The anguish of the sobbing woman in *Desperation* is reflected in all the elements at the artist's disposal: line, shape, space, light, color and texture. Separately and together, they all serve to accomplish the same end. This is what is meant by *unity* in a work of art.

Lines and shapes in this painting are long and stretched out, emphasizing an undernourished body, bony shoulders and elbows. Light reveals thin, elongated arms, and calls attention to oversized hands that must work hard to earn a living. Mostly in shadow, the woman's face is covered by her large hands, with only a furrowed brow to express her suffering. Background space is flat, divided into long and narrow sections that imitate the shapes of the woman's arms and body.

The unity of the picture is carried out in its overall texture, as rough and dry as earth that is hard to cultivate. Colors, too, are drab and claylike, and convey the same bitter message.

Like many paintings by Oswaldo Guayasamín, this one represents the artist's protest against injustices that create misery in the lives of Ecuador's poor.

• **Music (La música).** *José Luis Cuevas (born Mexico, 1933). Watercolor and ink, 1968.*

A variety of gentle rhythms gives *unity* to this painting, and each is in keeping with the title, *Music.*

Reclining against puffy pillows, the listening lady reflects an air of

Oswaldo Guayasimín. *Desperation (Desesperación)*. Oil on canvas, 1947. Collection of Museo Casa de la Cultura Ecuatoriana, Quito, Ecuador. (Photo courtesy of the artist.)

restfulness. But there is also rhythmic movement growing out of the medley of lines the artist used.

Notice the long, curving lines of the lady's shoulders and sleeves. They billow and move the way swelling musical sounds do. More movement flows from the rhythmic patterns of the tiny parallel lines (known as hatching) which Cuevas used to suggest shadows and to give objects a three-dimensional quality.

Another quiet rhythm comes from the hands and faces and other unpainted areas—like moments of silence between passages of music. Soft colors and textures add to the overall unity.

The artist's sense of humor gives a final unity to the picture. By turning his sketchbook, the artist within the painting has revealed a perfectly shaped ear on the underside of his page. Cuevas has tucked other ears into unexpected places as well.

• **Composition (Composición).** *Juan Batlle Planas (born Spain, 1911). Oil on canvas, undated.*

In this surrealist painting, three delicate-looking people seem to stagger under their own weight. At the same time they appear transparent and weightless. They are huddled together, supporting one another. Are they a family? Are they a group of friends? Does their closeness come from mutual suffering? Is their pain physical or mental, or both? Could this be a dream?

Unity comes from the delicate handling of the elements. Juan Batlle Planas's lines are simple, as if drawn with a fine pen and ink. Body shapes are long and slender. He created face and body shadows with thin washes of gray and brown paint. Even the heaviness of the dark earth was lightened by the artist's technique of "dripping" the blackness down from a splattered section of the white field. He added shades of gray and brown to every form, strengthening the work's unity.

The pale blue sky floats through the face of the middle person, and traces of blue appear in the other two faces. In the wide blue sky there is a suggestion of a dark cloud, matching the darkness of the earth, where the feet of all three figures are lost.

The unity of this painting includes its meaning, as hard to grasp as a half-formed thought flitting through the mind.

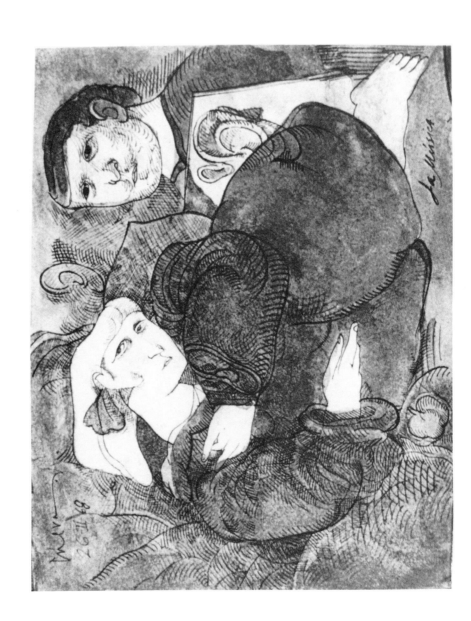

Above: Juan Batlle Planas. *Composition (Composición).* Oil on canvas, undated. Collection of Dr. and Mrs. Jorge Schneider, Highland Park, Ill. (Photo by Seymour Chaplik.)

Opposite: José Luis Cuevas. *Music (La música).* Watercolor and ink, 1968. Private collection. (Reproduction by courtesy of Galería de Arte Misrachi, Mexico D.F.)

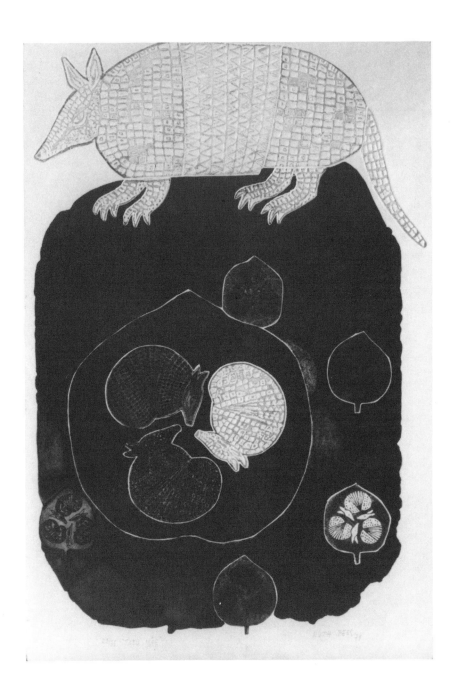

Ruth Bess. *Armadillo Mother (Tatu mãe).* Engraving, 1971. Collection of the Museum of Modern Art of Latin America, Organization of American States, Washington, D.C. (Photo by Angel Hurtado.)

• **Armadillo Mother (Tatu māe).** *Ruth Bess (born Germany, 1924). Engraving, 1971.*

A mother armadillo perches protectively on top of the underground hideaway of her young ones. The earthy tones and textures of the leaf pattern make an appropriate background for these burrowing creatures, who actually feed on vegetable matter.

By combining artistic imagination with scientific observation, Ruth Bess achieved a strong *unity* in this print. The unity comes from the way everything works together to describe the natural world of one of Brazil's native animals.

Three baby armadillos are curled up on the large center leaf. They seem to be a microscopic enlargement of the smaller ones rotating around them. Another pattern exists in the textured designs of the armorlike covering of the armadillos, mother and young ones alike.

Your eye moves in rhythm from texture to texture, from leaf shape to leaf shape, from tone to tone, from dark to light. The dark background gives added unity to the colors and shapes within it.

All the elements contribute to a realistic portrayal of the earthy environment and habits of the armadillo.

• **The Family.** *Marisol (born Paris, 1930). Painted wood and other materials, 1962.*

A no-nonsense family, simply dressed and stiffly posed, stares out at you. Their orderly lineup against a background of geometric shapes gives the portrait some of its *unity*. The artist's sense of humor connects the group in other ways.

Actually, each person is shown on a separate wood board, rectangular in shape. Behind the family are real double doors decorated with a curving scroll design that dips down toward each head and unifies the group by connecting them.

The people are unified, too, by their skin tones, coming from the natural color and texture of the unpainted wood, and by their straight-backed positions and serious faces (although one girl is smiling).

Marisol shows her playfulness in the materials she used to compose the portrait, particularly the shoes. At the left, the upper part of the girl's shoes

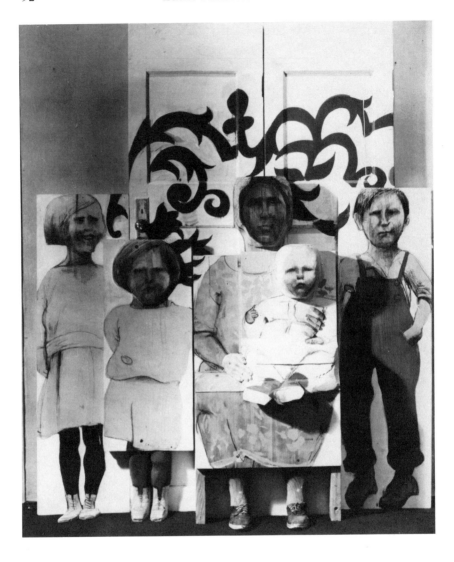

Marisol. *The Family*. Painted wood and other materials, in three sections, 6'10 5/8"×65 1/2"; 1962. Collection, the Museum of Modern Art, New York. Advisory Committee Fund.

are painted flat, but the toe part is carved from wood and rests on the floor, occupying actual space. The smaller girl's shoes, like her legs, are carved, and protrude from the panel the way the baby's shoes do. The mother wears real canvas gym shoes, while the boy's boots are sketched and painted, as flat as the rest of him. By giving interest to each pair of shoes, Marisol created an unusual unity.

What seems most important is the unity of the family itself.

Appendix: About the Artists

• Manuel Álvarez Bravo

The home in Mexico City where Manuel Álvarez Bravo was born in 1902 had an atmosphere that almost breathed art. His father was a painter, writer and amateur photographer. When he died while Manuel was still a small child, the boy began to spend time with his grandfather, also a photographer and painter, who encouraged his grandson's artistic nature. Manuel's sister Isabel remembers from childhood how creative her brother was, how he loved to make tiny altars and candlesticks and sing a Latin mass. Their mother was sure he would grow up to be a priest. Instead, it was the camera that won his heart.

A reluctant student, Manuel Álvarez Bravo left school at thirteen. To earn a living, he took a series of jobs doing copy-work, typing and accounting. At night he studied what he enjoyed most: painting, music and literature. Mexican life and culture fascinated him, and when he bought his first camera at twenty-two, he began taking pictures of the life around him. The family dining room became his makeshift darkroom.

By reading camera magazines, he developed skill in handling his camera, and won first prize in a photography contest at Oaxaca. After five years of taking pictures, he got a job teaching photography at Mexico's Academy of San Carlos. (His sister remembers that he was a "born" teacher, eager to explain camera techniques to anyone interested.) At the time, Diego Rivera was director of the Academy. He appreciated Álvarez Bravo's artistic and technical skills and commissioned him to photograph paintings by the Mexican muralists and other artists.

In 1931 Manuel Álvarez Bravo won first prize in another competition and sold one of his photographs to the Museum of Modern Art in New York City. At last he could give up his office job and become a full-time photographer. Other teaching appointments followed, along with

important commissions, more prizes and travel through Europe and Mexico.

Throughout his career, Álvarez Bravo's photographs have been in-spired by his love and understanding of his own country—its people, their problems and their needs. Like the famous muralists, he has concentrated on Mexico's working classes, but he has avoided politics. He often shows his subjects in a moment of silent thought, or reveals them in Mexico's natural light and shadow. He captures the spectrum of human emotion in his work, with an emphasis on the subject of death and dying.

In his eighties, Álvarez Bravo lives in Mexico City, with his wife and children. He still works, travels, exhibits his photographs and receives awards. In recent years he has been instrumental in collecting early photo-graphs for Mexico's new Museum of Photography, the first of its kind in Latin America.

Photographs by Manuel Álvarez Bravo have been exhibited throughout the world, and his works are a part of many private and public art collections.

• Alejandro Arostegui

Born in 1935 in Bluefields, Nicaragua, Alejandro Arostegui began his art training in his native country before coming to the United States in 1954. At first he studied architecture, then changed his mind and turned to painting. After two years, he traveled to Europe and studied in Florence and Paris.

In the early 1960s he returned to Nicaragua and established a gallery in Managua, which later became an important art center in his country. He went back to New York in 1966 for two years, this time to act as his country's cultural representative.

Studying in the United States and Europe has influenced Arostegui's style of painting, but his subjects are usually inspired by the scenes and at-mosphere of Nicaragua. He likes to paint its lakes, landscapes and coastlines.

Like big cities everywhere, Managua suffers from polluted air and lake water and accumulating debris, subjects that find their way into Arostegui's paintings. He often includes lonely, desolate human beings, surrounded by wasteland, vultures lined up on the shore, or the rubbish produced by city living. (On this last subject he painted an entire series of

pictures, called *Dump Yards*.) The gritty materials he adds to his paint give his work realistic texture.

Paintings by Alejandro Arostegui have been exhibited in Europe and the Americas.

• Héctor Basaldúa

Héctor Basaldúa was born in Pergamino, Argentina, in 1895, and had his first art training in Buenos Aires. Awarded a scholarship for one year's study in Europe, he ended up staying seven years. Most of the time was spent in Spain and France, studying modern art, something he had not seen in his native country.

Eventually, the theater became Basaldúa's great love. After returning to Argentina in 1930, he worked for many years as chief scenographer for the Colón Theater in Buenos Aires, designing sets for opera and ballet. An official invitation brought him to the United States in 1946 to study stage design and theater techniques. Later his government sent him to Europe to do additional research. But most of his time was spent in Buenos Aires, working on stage designs, easel painting, lithography and book illustrations.

For his lithographs and smaller works, he chose landscape scenes and still lifes as often as he did the human figure. Childhood memories frequently provided his subjects.

Before his death in 1976, many awards were given to Héctor Basaldúa for his painting and his scenography. His works are owned by museums and private collectors throughout the Americas and in Europe.

• Juan Batlle Planas

Born in Spain in 1911, Juan Batlle Planas was brought to Argentina by his parents when he was two years old. His parents kept their close ties to Spain, and their most intimate friends in Argentina had come from the same Catalonian region in Spain where they had lived. Because of his devotion to his parents, Juan grew up feeling like a man with two countries. For some people this can be an enriching experience, but it may have created conflicts for Juan Batlle Planas, making him unusually sensitive to

the workings of the inner mind. While still a teenager, he became extremely interested in the mind, the spirit and the inner self.

Not until he entered his family's business, at seventeen, did Juan emerge as an artist. While working in his family's engraving workshop, he learned to handle acids and metal plates. Teaching himself to draw, he soon began to etch into the metal plates. With the help of an uncle who was an artist, Juan became an excellent printmaker.

About the same time, he became curious about Zen Buddhism and took instruction from a Zen master. A few years later he became engrossed in psychoanalysis. As a result, he began using art to express inner emotions and tensions. For a while he considered giving up painting and printmaking to become a psychoanalyst, but decided to deal with the world of the unconscious mind through his art. He also wrote essays and gave lectures on the subject for many years.

Besides painting and printmaking, Juan Batlle Planas created collages and murals, illustrated books and decorated stage sets. From his first art show in 1939 until his death in 1966, the artist showed his work at hundreds of exhibitions in Argentina and throughout South America, winning many prizes. A year before his death, his work was exhibited for the first time in the United States.

• Cundo Bermúdez

Born in Havana, Cuba, in 1914, Cundo Bermúdez grew up dreaming about becoming an artist. One of his early memories is drawing on the large sheets of white paper in which the family laundry was delivered. Lying on the floor, he would fill the paper with drawings of little houses, human figures and the automobiles that were just beginning to replace horse-drawn carts.

He was an eager student, but his general education was interrupted several times when the schools were closed for political reasons. When this happened, he would spend more time drawing and painting. To earn a living, he worked at various jobs, including one that involved a process that separated colors for magazine illustrations. This work increased his understanding of color and was helpful to him later in his career as a painter, but he gave up the job when the intense light began to affect his vision.

In 1938, still unable to complete his education because of political problems, Bermúdez took his first trip away from Cuba and spent a few months

studying art in Mexico. Except for that experience and a brief period at a school in Havana, Bermúdez is a self-taught artist.

When school reopened in Cuba, Bermúdez went back to the University of Havana and received a degree in diplomatic law in 1941. Afterwards he made trips to the United States, Haiti and Europe. In 1952 he returned to Cuba and devoted himself completely to painting. In addition, he designed a ceramic tile mural for the exterior of a hotel in Havana.

Since 1967, he has made his home in Puerto Rico, living quietly in a bachelor studio apartment in San Juan. A shy man who prefers painting to talking, Bermúdez enjoys living in Puerto Rico, where the tropical light and atmosphere remind him of his native island.

Not long after arriving in Puerto Rico, Bermúdez designed two two-hundred-foot-high mosaic tile murals on the exterior of a new building in San Juan. He traveled to Italy personally to select the stones to carry out the brilliant color patterns so important to his art. He acknowledges that Cuba's luminous light and color, along with its Spanish and Negro influences, have given a strong sense of color to most Cuban artists.

Since his first art show in a small public park in Havana, in 1937, Cundo Bermúdez has exhibited his work frequently in Cuba, the Americas and a number of European countries. His paintings are owned by many private collectors and public museums, including the Museum of Modern Art in New York.

• Antonio Berni

Antonio Berni grew up in a prosperous Argentine farming community, quite different from the background of many of his pictures, which deal with life in the poorer quarters of the large city of Buenos Aires.

Born in 1905, in Rosario, Santa Fe, Berni studied art there and gave his first exhibition at the age of sixteen. A scholarship won in 1925 offered him a chance to travel and study in Europe, and after six years of living and working in Paris, he returned to Argentina and became an art teacher. In Buenos Aires he painted murals with the Mexican artist David Alfaro Siqueiros, and under his influence, Berni began to put social messages into his art.

People were always important to Berni, and in his early work, he painted them in a strong, realistic manner. His style grew out of his

admiration for the Italian Renaissance artists and for the Frenchman Pierre Auguste Renoir.

As he developed, his painting became more abstract and imaginative, but his subject matter always came from real life. Out of his concern for people, he invented a young hero, Juanito Laguna, from the slums of Buenos Aires. In a series of pictures he shows Juanito with his family and his friends. Juanito's experiences are typical of boyhood everywhere, but they also describe what it is like to grow up in the poor, tough section of Buenos Aires. Not long after inventing Juanito, Berni introduced Ramona Montiel, an imaginary girl from the slums (see *Ramona in the Show*).

In keeping with the real-life subjects of his work, Berni often uses real-life materials, such as bits of old lace, scraps of sequined dresses, buttons, and pieces of string.

Over the years the artist's collages, prints and paintings have been shown in countries throughout the Americas and Europe, and many prizes have been awarded him. Antonio Berni's art is owned by museums and private collectors in various parts of the world. He has homes in both Paris and Buenos Aires.

• Ruth Bess

Spanish on her father's side, Ruth Bessoudo Courvoisier arrived in Latin America from Europe after the Second World War. She was born in Hamburg, in 1924, and grew up in Germany. Her mother was a well-known German actress of Greek descent and her father was a Spanish Jew who fled Germany before the outbreak of war. His wife and daughter were not permitted to leave the country, but through her father, Ruth Bess was a Spanish subject and thus protected from the fate of other Germans of Jewish extraction.

Although Ruth Bess had studied art in Paris, Copenhagen, and Hamburg, she was forbidden by the Nazis to work as an artist. When the war was over, she returned to her art, creating posters for the British Occupation Army's theatrical performances. When a former school friend, a French poet and journalist living in Venezuela, asked Ruth to join him, she was happy to leave the country where she had seen and experienced so much injustice and abuse.

In Venezuela she worked first as a magazine illustrator, then founded a film magazine, *Venezuelan Cine*, with the French journalist, whom

she married. Later she and her husband moved to Rio de Janeiro in Brazil.

Traveling through the South American jungle, Ruth Bess became fascinated with the dense tropical growth and wild life. From childhood she had dreamed of the mysterious tropics, and found it exciting to explore them firsthand. In a letter to the author, Bess writes, "I begin to adore this Fauna and Flora . . . animals and big leaves. . . ." The shapes and textures of the tropical leaves lent themselves well to etching on metal plates, a technique the artist began using to record Brazil's natural life. (See *Armadillo Mother*, page 90.)

From the beginning, Bess's printmaking was encouraged by one of Brazil's foremost writers, Jorge Amado, who saw and admired her work. In her years of residence there, Brazil claimed Bess as one of its leading graphic artists, and called on her often to represent the country in international exhibitions.

Recently Ruth Bess has been living in Venezuela, but she has not lost her affection for Brazil, and looks forward to the time when she can return. She says, "I like the sun, the beach and the tropical way of life . . . such a big contrast to my life before in . . . cold Hamburg."

The work of Ruth Bess has been displayed in countries around the world and has won many awards. Her etchings are a part of public and private collections in Europe and America.

• Fernando Botero

The city of Medillín, Colombia, where Fernando Botero was born in 1932, is a center for commerce and industry. Except for pre–Columbian works and colonial church art, Medillín offered little opportunity for a young artist to study original paintings, particularly modern art. Botero taught himself to paint by poring over copies of old masterworks and by following their techniques. At his one-man show in Bogotá, in 1952, his paintings were done in so many different styles that people thought they were the work of several artists.

The money Botero earned from the sale of his paintings paid for a trip to Europe. Although he had planned to dedicate himself to modern art, it was the work of the Spanish artists Goya and Velázquez that moved him most. Instead of concentrating on the modern masters, he devoted himself to careful, disciplined study of the artists of the past, working at the Prado

in Madrid, the Louvre in Paris and the museums of Italy. In his own paintings, he imitated their meticulous attention to figures, textures and colors.

When he returned to Colombia in 1955, Botero found that people disliked his new works, complaining that they were too traditional, not modern enough. Although he felt he had failed as an artist, Botero continued to work, spending time in the United States and Mexico. In time, his paintings were accepted, and today he is one of Colombia's most celebrated artists.

While Botero's style of painting derives from the old masters, most of his subjects come from contemporary life, often reflecting his Colombian background. Sometimes he borrows ideas from the past, but whether he paints a bouquet of flowers, a bowl of fruit or a portrait (including his own), Botero makes his subject very plump. Even his painting of Leonardo da Vinci's *Mona Lisa* makes her look as if she had overeaten.

Internationally known today, Botero divides his time between Paris, New York and Colombia. A fellow artist visiting him at Bogotá described his studio as neat and antiseptically clean, with no decorations on the white walls. He noted that Botero seemed more interested in showing the flowers growing on his farm and the water flowing from the mountains to irrigate his fields than in displaying his paintings.*

Between 1975 and 1977, Botero stopped painting and turned to sculpture. Many of his pieces reflect Colombian folk art, and most of them have the same voluptuous quality of his paintings. When sculpting, Botero works from sketches, and models his figures in plaster before having them cast in bronze.

Fernando Botero's art has been exhibited throughout the world and is represented in many private and public collections.

• Emiliano Di Cavalcanti

This native Brazilian artist, Emiliano Augusto Di Cavalcanti, was born in 1897, in Rio de Janeiro, and lived there until he was nineteen. At that time he was studying law, but he changed his mind about his career after his successful exhibit of caricatures in Rio's Salon of Humorists. Deciding to become a professional artist, he moved to São Paulo, where

*José Y. Bermúdez, *Américas*, Oct. 1973.

eventually he played an important role in the development of modern art. To begin with, he made a living by illustrating books and drawing caricatures.

Together with two Brazilian writers and a core of modern artists, Cavalcanti created the original idea for a famous event in Brazil's cultural history. It was known as São Paulo's Week of Modern Art, and it took place in 1922. Painters, poets, writers and musicians met in the Municipal Theater throughout that week to demonstrate the latest trends in each art form.

Until then the Brazilian public had seen very little modern art, and not understanding what they saw, they reacted with anger to the contemporary expressions. Viewers attacked the paintings and protested the music and poetry, while leading newspapers carried abusive articles.

In spite of the hostile responses, modern art did survive, and young artists were soon following the lead of Cavalcanti and his companions. Thanks to them, São Paulo is known today throughout the world for its international art exhibitions that take place every two years.

The year following the famous Week of Modern Art, Emiliano Di Cavalcanti left Brazil to study in Europe. The twentieth century modernists in Paris excited him, especially the art of Pablo Picasso. When he returned home, he adapted Parisian art styles to the Brazilian way of life.

His paintings of street scenes, carnival time, the elegantly dressed and the poor are considered among the most faithful descriptions of life in Brazil. The human figure is usually prominent in his work. In particular, he liked to paint Brazil's black people—their skin tones, the color of their clothing and the rhythms of their movement.

Painting in Brazil the remainder of his life. Emiliano Di Cavalcanti died in Rio de Janeiro in 1976, at the age of seventy-nine. His work is well known in the Americas and in Europe, and many honors and prizes were awarded to him.

• José Luis Cuevas

In his own words, José Luis Cuevas says, "I was born on a February day in 1934. Though Mexico City is always chilly, they tell me it was an unusually harsh winter. I was taken to a building in Triumph Alley where my family lived over a paper mill. My first recollection is of paper

trimmings scattered over the floor like fallen streams and confetti from the paper puncher. . . ."*

The paper of Cuevas's earliest memories has become the constant companion of his life. From the age of four he was using the scrap paper from his grandfather's paper mill for drawing and painting. Today he works with pen and ink and colored washes on paper, and executes many lithographs and engravings, where the picture is transferred to paper in the printing process.

In spite of Cuevas's early talent, his parents were opposed to his making a career of art. They thought he would never make a living with it. His father was a pilot, and his mother came from a well-to-do Yucatan family. Cuevas's brother became a psychiatrist and his sister a nun, and his parents would have liked José Luis to choose a more conservative profession.

From the time he was ten or eleven, Cuevas spent long months in bed as a result of rheumatic fever. To escape the reality of his serious illness, he spent his time sketching or reading. The European writers Dostoevsky and Kafka had enormous influence on the way he perceived human nature. As he developed as an artist, Cuevas was strongly influenced by the Spanish artists Goya and Picasso and by the Mexican painter Orozco.

As a young man, Cuevas wandered the streets of Mexico, searching for models among life's less glamorous people—beggars, prostitutes, peddlers, dwarfs, etc. When his brother was studying medicine and psychiatry, he introduced José to hospitals for the poor and the insane, inspiring a series of works by the artist. His first important series of drawings was based on corpses he had seen at a medical school.

In painting from life's harsher realities, and his preoccupation with death, Cuevas follows a Mexican tradition. But unlike most of the Mexican muralists and many other artists who came before him, he avoids the politics of Mexico. His tragic themes are universal, understood by people everywhere.

Many of Cuevas's works suggest hallucinations and nightmares. The painting called *Music* (page 88) is a rare example of a lighter, more carefree moment recorded by the artist. But the painting's expressive, flowing lines and the sometimes blurry edges of color are typical of his style. Often Cuevas paints himself into a picture, either as a spectator or an actor.

*Text from drawing in collection of the Museum of Modern Art of Latin America, Organization of American States, Washington, D.C.

(Obsessed with his own likeness, Cuevas begins each day by sketching himself, right after awakening.)

Whatever his work, Cuevas labors rapidly, preferring to finish the same day he begins, sometimes drawing without looking at the paper, his hand moving swiftly as he keeps his eye on the model. Often he works without a model, relying on memory and imagination. Almost every moment of his day is filled with sketching: while he chats on the telephone, gives lectures, or dines at a restaurant.

Because of poor health, Cuevas left Mexico in 1976 for a seven-year stay in Paris, where he found life calmer and less distracting. He rented a quiet studio near Place Pigalle, and allowed nothing to interfere with his artistic production. Working with outstanding French printers, he learned new techniques of engraving.

Despite his family's fears that he had chosen the road to poverty and hunger, José Luis Cuevas became a successful artist at an early age. Besides painting and printmaking, he has recently executed several pieces of sculpture. In addition, he has illustrated many books and written several volumes about his own life. His works are owned by private and public collectors throughout the world.

• Pedro Figari

From the paintings of this artist one can learn something of the history and geography of one of South America's smallest countries. Pedro Figari was born in Montevideo, Uruguay, in 1861, of parents who had emigrated from Italy. Many years of Figari's long life were spent painting the land and people of Uruguay as he remembered them from childhood. Besides being an important artist, he was a prominent attorney, writer and diplomat.

During the early part of his career, Figari thought of himself as an amateur painter, and devoted himself mostly to the practice of law. He championed social justice and helped to change the criminal laws of Uruguay. In 1916, at the age of fifty-five, he gave up his law practice to paint full time.

Although in his youth Figari had studied art briefly with an Italian teacher, he was largely a self-taught painter. Moving to Paris after his retirement from public life gave him the opportunity to observe firsthand the works of famous contemporary artists. The influence of the French

impressionists as well as the German expressionists can be detected in his own primitive style.

Painting from memory, Figari liked to work with oil paint on *cartón*, an absorbent cardboard that produced a heavy, rich surface. His subjects were varied, but he preferred scenes at dawn or dusk, both shadowless times of day. Many of his landscapes are without people. They show Uruguay's wide and arid fields, a high sky and an occasional *ombú* (umbrella tree) on the horizon.

Other times the artist depicted the lives of the gauchos at work or at play, government leaders, soldiers and elegant ladies at parties inside richly furnished colonial houses. Another favorite subject was the colony of black people who had come to Uruguay to escape Brazilian slavery. Figari loved to paint their brilliant-colored clothes and their festivals.

When he died in 1938, Pedro Figari left hundreds of such paintings, describing the land and the life he and his parents had known in Uruguay in the middle of the nineteenth century. Today his works are treasured by private collectors and public museums throughout the Americas as well as in Europe.

• Raquel Forner

One of the world's first space artists, Raquel Forner was born in Buenos Aires, Argentina, in 1902. Drawing and painting from childhood, she showed an interest in people and the environment in her earliest portraits and landscapes. Her later works reflect her concern for the future of humankind.

The artist's early training in Buenos Aires was traditional. Through magazines from Paris and Munich she learned about the modern art movements in Europe. She was particularly interested in expressionism, a style first developed by twentieth century German artists who distorted lines and shapes in order to express powerful feelings.

When Raquel Forner was twenty-seven, she went to Europe to study art. In Spain, the homeland of her parents, she saw sixteenth century paintings by El Greco, and was deeply moved by the way he distorted his figures, as well as by the colors and religious strength of his works.

Traveling to Italy, Germany, England and France, she continued to paint and study. Settling in Paris for a while, she studied with Othon Friesz and worked with a group of Argentine artists, including the sculptor

Alfredo Bigatti, whom she later married. When she returned to Buenos Aires in 1931, she founded an independent art school, together with Bigatti and painter Alfredo Guttero.

As Forner's own work developed, it became increasingly powerful and abstract. Her concern for people was always of great importance. When the first satellites were launched, she began a series of paintings about space, showing astro-beings and earthly people of the future. Her figures are strange mutations, wild-looking creatures against wild-looking landscapes.

Though her images are forceful and sometimes frightening, Raquel Forner explains she is not a pessimist. She feels her art is a warning about the dangers of the future. But she is certain people will triumph, that they will be wiser and more humane as the result of their experiences.

Today the artist lives and works in Buenos Aires. When she is not painting, she is attracted to the sea, where she likes to wander along the beach, collecting snails, picking up seaweed or just gazing at the horizon. These things refresh her and inspire a continued devotion to themes on the dignity and destiny of the human race.

Raquel Forner has won many national and international awards. Her paintings hang in private and public art collections throughout Europe and the Americas.

• Antonio Frasconi

When he was two weeks old, Antonio Frasconi was taken from Argentina, where he was born in 1919, to Montevideo, Uruguay, where he grew up. His parents had immigrated to South America from Italy. Remembering the awesome religious paintings that hung on the walls of their village church, Frasconi's mother was certain that painting was the holy gift of divine hands. She believed anyone destined to do such work would not have been born into a working class family in the restaurant business.

Despite his mother's discouragement, Frasconi pursued a career in art. This was in addition to other responsibilities, such as marketing for the family restaurant and drawing graphs in a government office. By the time he was in his teens, he was drawing political cartoons for newspapers in Uruguay.

Today, working in the United States, Frasconi continues to create political art, protesting injustice and oppression wherever he sees it. Many

of his woodcuts are portraits of social activists. He also creates nonpolitical art inspired by everyday life, and illustrates books.

As a young man Frasconi studied at night for a short time at an art school in Montevideo. But he taught himself the technique of carving and printing from blocks of wood, his favorite medium. A knife, a piece of wood, and a table on which to work are all he needs. Sometimes he finds leftover scraps of wood in lumber yards, or uses fruit crates from the supermarket. To print his pictures, he often uses the ancient method of rubbing a spoon over a paper laid on an inked block of wood.

Most of Frasconi's early woodblock prints were made in black and white, and reflected the simple farm life of Uruguayan peasants. He began creating color prints after his arrival in the United States on an art scholarship in 1945. His first color prints depicted rural life in North America.

Since then Frasconi has produced thousands of woodcuts, and his style and technique have influenced other artists. In recent years he has become interested in rubber-stamp art and has experimented with the use of color xerography in his printmaking. He also has illustrated many books, including several volumes of poetry and a number of multilingual books for children.

Today Antonio Frasconi lives in Southwalk, Connecticut, and works in a studio a few steps from his home. He is well known as a teacher and artist, and his works are owned by museums and private collectors all over the world.

• Marcelo Grassmann

Born in São Paulo, Brazil, in 1925, Marcelo Grassmann never attended art school and is completely self-taught. Besides being skillful with pen and pencil, he is an expert printmaker, one of Brazil's most famous. He began his art career as a woodcutter, printing pictures from carved blocks of wood; then he progressed to using metal plates for etchings and engravings, and later began drawing on stone (lithography).

Exotic animals and strange creatures are the subjects of most of Grassmann's pictures, giving them a fantastic, dreamlike quality.

Since his first art exhibition in Brazil at the age of twenty-one, he has shown his work in countries around the world. Many prizes have been awarded to him for drawing and engraving, including an award in Venice for religious art. One of his early prizes was a trip to Europe, giving him the

chance to travel and study the work of other artists, as well as to exhibit his own work there.

Marcelo Grassmann's work hangs in art museums in the Americas and Europe, as well as in private collections.

• Oswaldo Guayasamín

The first of ten children, Oswaldo Guayasamín was born in 1919, in Quito, Ecuador, to an Indian father and a mestizo mother. Raised in poverty, he began to sell his own small landscape sketches when he was ten years old. By peddling them on the streets to tourists, he earned enough money to pay his tuition at Quito's School of Fine Arts. He had difficulty making a living, even after finishing school.

His luck changed with the arrival in Ecuador of a North American visitor, Nelson Rockefeller. At the time, Rockefeller was Coordinator for Inter-American Affairs, and he happened to attend Guayasamín's first one-man show in Quito. Rockefeller spent two hours looking at the paintings and took four or five away with him. Within a week a check arrived for 30,000 *sucres*, a large sum of money. It was the high point of Guayasamín's career, since few people in his country understood his work at that time, and he was selling pictures cheaply.

Soon afterwards, the United States government invited the artist to tour America's great museums. At the National Gallery of Art in Washington, D.C., he was so moved by his first sight of an El Greco painting, *St. Jerome,* that he fell to his knees as if he were in a house of worship.

Afterwards he traveled to Mexico to study mural painting with José Clemente Orozco. The influences of El Greco, Orozco and, later, Picasso, were important in Guayasmín's development, but the artist claims his painting style is completely his own.

During two years of travel through the villages of Central and South America, Guayasamín made about 3000 sketches of Indians, mestizos and Negroes. The sketches were the basis for a series of 103 larger works, titled *The Road of Tears,* finished in 1951, after five years of work in his studio. The painting *Desperation* (page 86) is part of this series.

A trip around the world inspired another series of paintings called *The Age of Wrath.* Turning his vision away from his own country, Guayasamín found new subjects in world events: Spain's Civil War, World War II, the

concentration camps, the Vietnamese War and other tragedies of hunger, strife and misery experienced by people around the world.

Far from the poverty of his youth, today Guayasamín lives in a mansion of his own design, on a mountainside overlooking Quito. Two studios within the home provide working space for him. Nearby stands a museum gallery housing his collection of pre–Columbian and colonial Ecuadorian art, along with his own paintings and the work of other Latin American artists.

The paintings of Oswaldo Guayasamín have been exhibited in many far-off places and hang in collections all over the world.

• Lorenzo Homar

Before becoming an artist, Lorenzo Homar had careers as a gymnast, a jewelry designer and a soldier. He was born in San Juan, Puerto Rico, in 1913, and migrated with his family to the United States when he was fifteen. By then he was a disciplined gymnast, having spent long hours practicing to music in the years before leaving Puerto Rico. In New York City he became part of a group of acrobats who worked out at Coney Island, and eventually this led to his career in vaudeville.

At Coney Island, Homar met the artist Reginald Marsh, who frequently came to paint the gymnasts and the crowd scenes there. Marsh befriended Homar and encouraged him to continue his own drawing, done for the most part on the subway train while Lorenzo was going to and from his job as a messenger.

Homar attended art school at night and later took a job as an apprentice to a jewelry designer. Learning to handle engraving tools and working on precious stones and metals, he strengthened his sense of design. These experiences prepared him for his career as a printmaker when he returned to Puerto Rico in 1950, after serving in World War II.

Except for brief periods of travel and study, Homar has remained in Puerto Rico since then. At home he helped to establish important centers for the study of art and organized the Graphic Arts Department of the Escuela de Artes Plásticas in San Juan, where he now teaches.

Although Homar has worked in many media, his forte has been engraving and the silk screen process, to which he brings his strong sense of color and design and a passion for calligraphy. All of Homar's work

reflects his deep involvement with Puerto Rico: the land, the sea, its animal world, the people, their culture and their problems.

The same discipline that made Lorenzo Homar a fine acrobat and a careful jewelry designer is seen in his orderly, well-run studio workshop in San Juan, where he creates scenography for the theater, murals, political cartoons and illustrations for children's books, in addition to painting and printmaking.

Works by this artist are owned by many public and private collectors in Europe and the Americas. In homage to Lorenzo Homar Gelabert, the Museum of Art of Ponce, in Puerto Rico, presented in 1978 a retrospective exhibition of his work, displaying paintings, drawings, posters, book illustrations and other graphics.

• Angel Hurtado

A painter as well as a filmmaker, Angel Hurtado grew up in a home that nurtured the two talents. Born in 1927 in El Tocuyo, Lara, Venezuela, Hurtado learned first about painting from his mother and grandmother, both artists. The world of cinema came to him through his father. By the time he was five years old and had learned to print the alphabet, his father had trained him to paint the letters on posters he was making for the theater. At night he would help his father mount the posters at the theater or at the ticket seller's establishment. Soon Angel was working as a projectionist as well.

While still a youngster, Angel frequently accompanied Tocuyan artists to the countryside, where he watched them paint. Before long he was making his own charcoal sketches of the landscape, and at seventeen he decided to make painting his career. A scholarship made it possible for him to attend an art school in Caracas, where he studied for four years.

Art school was a time of hard work. He did not always agree with his teachers, but his own goal was to thoroughly work out the individual problems of painting, concentrating at all times on careful workmanship. Ignoring the fashionable trends followed by other artists, he followed his own instincts.

As Hurtado continued to paint, he found himself more concerned with color and space than with realistic forms. He says, "My landscapes

were becoming pure painting. . . . What I created, to give it a name, is spatial art."*

He feels the photograph and the film do the best job of reproducing the real landscape, and, therefore, the artist must look for new landscapes within himself. He says, "This interior world is richer, by far, than the exterior world. . . . What I attempt to do is cause the spectator to search within himself in front of the painting."*

In his twenties, Hurtado lived in Europe and traveled through several countries, studying both art and filmmaking in Paris. On his return to Caracas six years later, he was made Cinematography Director for National Television, and taught filmmaking at the Central University of Venezuela. Since then he has made numerous films, most of them related to the arts.

Many awards have been made to Angel Hurtado for his paintings and his films. Today he lives in Washington, D.C., and still pursues his dual career. He heads the Department of Cinematography for the Organization of American States, and recently has been acting director of the Museum of Modern Art of Latin America. Hurtado's works have been shown throughout Europe and the Americas.

• Frida Kahlo

A tragic accident when she was fifteen changed the life and character of Carmen Frida Kahlo de Rivera. She was born in 1910, in Coyoacán, Mexico, of a Mexican mother of Spanish-Indian descent and a German-Jewish father. By the time she was thirteen, she had a reputation for madcap pranks and was the ringleader for a group of boys and girls involved in mischief-making. Twice she was expelled from school, but her good scholastic record helped to get her reinstated.

The collision of a streetcar with the bus she was riding home from school in Mexico City left her with a badly broken body. The surgeons did not expect her to survive at first, then feared she would never walk; but after eighteen months of recuperation, most of it while she lay flat on her back encased in plaster casts, Frida emerged a quiet, subdued young woman. Although she was left lame and in constant pain, she never lost her gaiety and quick wit.

*Rafael Delgado, La Pintura de Angel Hurtado, 1969.

During her long months in bed she began to paint, with an easel strapped over her. When she recovered, she sought advice from Diego Rivera, whom she knew by reputation. Approaching the scaffold where he stood painting murals one day, she boldly asked him to climb down and give her a professional opinion of her paintings. He encouraged her to develop her obvious talent. More than that, Rivera took her under his wing, courted and married her by the time she was nineteen.

From the beginning of her career, Kahlo's art was highly personal, differing from her husband's in both style and subject. While most of her themes are Mexican, her own face appears in many of her paintings, emphasizing the personal nature of her art.

One series of small paintings on tin was begun during another hospital experience, this time due to the loss of a pregnancy. Her inability to bear children was a result of her original accident. When she was confined to bed again, she turned to painting as an outlet for her grief. A number of works in this series are related to childbirth and express her suffering and sorrow.

At a Paris exhibition of her art in 1939, Vassily Kandinsky, one of the pioneers of abstract art, was so moved by her work that in front of everyone, he lifted Frida in his arms and kissed her as the tears ran down his cheeks. Pablo Picasso also praised her paintings.

Being two strong personalities, Frida Kahlo and Diego Rivera had a stormy life together. There was a separation, a divorce, and then remarriage to one another. In the end, their mutual concern and need brought them together again.

The year before her death, Frida Kahlo attended her last exhibition in Mexico City, transported to the gallery in a stretcher by an ambulance. On her death in 1954, her house in Coyoacán was left to the Mexican government as a museum. Everything in the house remains as it was at the time of her death.

• Wifredo Lam

Cuban-born Wifredo Lam, one of the world's celebrated surrealist painters, was truly an international man. His father was Chinese and his mother part African, part American Indian and part European. For many years before his death in 1982, Lam lived in France with his Swedish wife and their family.

Youngest of nine children, Wifredo Oscar de Concepción Lam y Castillo was born in 1902, at Sagua la Grande, Cuba, and learned at an early age the meaning of prejudice. Although his mother was from an old and well-known Cuban family, he was always referred to as the son of the *chino*.

Lam's father was proud of his heritage and shared many Chinese traditions with his family, but Wifredo grew up with a strong Negro identification. From his mother, he inherited ties to Africa and an awareness of the supernatural known to most Afro-Cuban religious cults. His godmother was a professional sorceress who introduced him to the world of spirits, sacrifices and spells. She hoped Lam would be a sorcerer when he grew up.

Though Lam developed a strong belief in the power of reason, he kept the vivid sense of the supernatural that grew out of his boyhood experiences. The folklore of his people, together with the rich vegetation of Cuba, provided him with unique symbols to enrich his surrealist art. His canvases are filled with stalks of sugar cane and bamboo, and the fantastic visions of his early world.

After studying art in Havana, Lam spent several years in Spain, joining the fight for Madrid in that country's Civil War. In Paris, he met Pablo Picasso, who came to see Lam's first exhibition in 1938. Picasso took an interest in Lam's work and became his close friend. He made sure Lam had the light, space and materials needed for painting, and sometimes took the poor young artist to dinner. Lam once recalled Picasso's comment that the hungry Lam might eat the leg of the table, if given the chance.

In the same period, about 1939, Lam met the surrealist painters working in Paris and joined their official group. Lam's fantastic images and the free play of his imagination made him a welcome member of that group. Picasso and the surrealists had a marked influence on his painting, but Lam's Afro-Cuban background was the strongest influence on his style.

During and after World War II, Lam lived periodically in Cuba, New York, Paris and, for a short time, in Chicago. Works by Wifredo Lam have been shown around the world and are owned by private and public collectors in many countries.

• Mauricio Lasansky

Printmaking was a natural career for Argentine-born Mauricio Lasansky. His father and uncle were printers, and the artist once said that he

must have come into the world with printer's ink in his veins. He was born in 1914, in Buenos Aires, to an Argentine mother and a Polish father. As a boy, he studied music, but when he developed a temporary hearing problem at fourteen, he turned to art.

At nineteen, Lasansky graduated from the Superior School of Fine Arts in Buenos Aires, and when he was twenty-two years old, he was made director of an art school in Córdoba. By then he was a skilled printmaker, having first learned from his father to use copper and zinc plates for printing pictures.

In 1940, an art director from New York was traveling in South America and saw Mauricio Lasansky's prints. He was impressed with his talent and skill and recommended him for a Guggenheim Fellowship, to study in New York.

Lasansky was eager for a broader art education. Argentina's lively theater and music circles were exciting, as was the Spanish literature he read, but there were few exhibits of art from other countries. All he knew of modern art was what he read in books, and he wanted to know firsthand what was happening elsewhere.

When he arrived in New York City in 1943, Lasansky visited the Metropolitan Museum of Art, where he examined every one of the 150,000 prints in its collection. He studied with a famous teacher, Stanley William Hayter, and learned new methods of printmaking. It was in New York that he saw Picasso's art for the first time, and he was greatly influenced by it.

When the fellowship ended, Lasansky decided to settle in the United States, and he sent for his wife and two children, although he had no job, no money and little knowledge of the English language. Fortunately, he was offered a teaching job soon afterwards at the University of Iowa, and he helped to establish their print department. Later he became a full professor and still heads that department.

Since those days Mauricio Lasansky has acquired a worldwide reputation as artist and teacher. His prints are among the most powerful and expressive works by a modern artist in any medium. Throughout his career, he has chosen the human figure as his subject, often rendering it larger than life-sized.

Many honors and awards have been made to Mauricio Lasansky. His works have been exhibited and are owned by museums and private collectors all over the world.

• Augusto Marín

The cluttered studio of Augusto Marín in Old San Juan, Puerto Rico, is very much an artist's workshop. Books on art and philosophy fill the shelves. Standing about are rock formations, pieces of sculpture and plaster casts. Portfolios are stuffed with drawings and small paintings. Easels, ladders, brushes, papers, paints, bags of plaster and containers of glue are piled up everywhere.

Finished and unfinished paintings, framed and unframed, lean against the studio walls, most revealing Marín's regard for religious figures. Although he is not a regular churchgoer, religious training was an important part of his early education, as it is for most Latin Americans. Today the subjects of many of Marín's paintings are Christ figures, Madonnas, people of the Old Testament and characters from the ancient Greek and Roman religions.

Augusto Marín was born in San Juan in 1921. During some of his growing-up years, he lived near a racetrack, where he admired the strength and beauty of the racehorses. Today horses are still a favorite theme, often included in his drawings, murals, easel paintings and graphic works.

At thirteen Marín started to study art seriously. After a year and a half with a local art teacher, he began to work alone. Later, after serving in World War II, he spent six years attending art schools in New York and Los Angeles. Already he was the father of three children, and to earn a living, he worked as art director for a Spanish magazine and for an advertising agency. Today several of Marín's eight children have chosen to follow their father's footsteps into the art field.

Marín makes his home now in Puerto Rico, where he teaches, paints, draws and creates murals. A mosaic tile mural (126 feet long and 11 feet high) designed by Marín decorates one of San Juan's newer buildings. The mural incorporates complex symbolism from the Taino Indians, the people who lived on the island before the Spanish conquest.

Besides designing murals and painting, Marín does silk screen printing. He feels printmaking is a good medium for reaching a large number of people, since a single work can be printed many times.

Speaking with the author, when asked what was Puerto Rican about his work, Marín replied, "It is not the intense colors I sometimes use, but it is the striving for independence in my art." He feels this is a reflection of his people's struggle for independence in their growth as a country.

• Marisol

Venezuelan parents gave Marisol Escobar her tie to Latin America, although she was born in Paris and received much of her education in the United States. Some experts see her work as influenced by the pre–Columbian art of South America, especially in her frequent use of plaster masks. Some see the kinship of her work to peasant woodcarving or folk art. Still others relate her to the New York school of "pop" art and to various modern trends. For the most part, however, her art represents something personal and unique, often mirroring her unusual sense of humor.

Marisol's personal humor is reflected in the way she once conducted a lecture to a group of artists. She appeared on the platform wearing a Japanese mask, and when the audience called out for her to remove the mask, she revealed her own face painted precisely the same as the mask.*

Born in 1930, Marisol moved about frequently with her family and arrived in Venezuela when she was five years old. She attended school there and recalls how she was required to copy pictures of saints as her introduction to art. From the start she drew well and won prizes for her work.

Her adolescent years were spent in Los Angeles and Paris. In Los Angeles she attended high school and began to study art seriously, and in Paris she attended the École des Beaux Arts and the Académie Julian. In 1950, she settled in New York City, enrolling at the Hans Hofmann School and the Art Students' League. Later she spent two years in Rome.

Marisol's training was in the field of painting. On her own she developed a mixed-media technique that involved painting, drawing, stenciling, casting and carving. With no training in sculpting, she learned about materials and tools by trial and error; or by calling a factory for instructions; or by asking other sculptors for advice.

Occasionally she uses ordinary sculptor's materials, such as blocks of wood or stone. Other times she uses planks of pine from the lumberyard to create figures that are nailed or glued together and carved in a special way. Her tools include rasps, chisels, files, power drills, power handsaws and power sanders. Often she incorporates pieces of fabric, sometimes actual wearing apparel, in her constructions, as well as plaster-cast molds of her own face, hands, arms or legs.

Many of Marisol's figures represent family groups, seen by some as a

*Jacqueline Barnitz, *Hispanic Arts*, Autumn, 1967.

reaction to her lonely childhood. The figures she creates are sometimes in-spired by photographs discarded by others and picked up by chance by the artist.

In recent years she has done realistic portrait sculpture of well-known people who have influenced her life or her artistic development. She has also produced many prints and drawings.

Marisol's work has been shown in a number of countries and is a part of private and public collections around the world.

• Matta

Roberto Sebastian Antonio Matta Echaurren was born in Santiago, Chile, in 1911, of Spanish lineage. He once told a story to explain what Spanish heritage could mean to an artist. The story was about a thief, dressed in his finest clothing, who walked along the quays in Barcelona, stealing lemons and throwing them into the river. Arrested and brought to court, he explained to the judge that he had never seen the river so black nor lemons so brightly yellow. With this explanation, the thief was given his freedom. Matta pointed out that it could only have happened in Catalan Spain.*

As a young man, Matta studied architecture to please his family, and in 1933 he went to Paris to work in the office of the famous architect Le Corbusier. But Matta really wanted to be a painter and spent most of his time traveling through Europe and studying art.

In Spain he met the artist Salvador Dalí, who directed him to the group of surrealist painters working in Paris. He exhibited his first three drawings with them and officially joined their group in 1937. Matta's abstract forms and his automatic or unconscious drawing style were characteristics the surrealists embraced. As Matta developed, his unique handling of space, particularly the absence of a horizon line in his work, as well as his treatment of color and movement gave his art its distinction. Looking back at his early work, many people see in Matta something of a prophet, because before the atomic era began, his pictures suggested ex-plosions and blown vapor swirling in space.

When World War II broke out, Matta had to leave Paris because he had openly opposed Hitler and feared pursuit by Germany's S.S. troops.

*James Thrall Soby, *Magazine of Art*, March 1947.

With his young American bride, Matta moved to New York City and became an important force in New York's growth as a modern art center. At the war's end, he returned to Europe and tried to record in his work the tension and changes taking place in postwar Italy and France.

World-famous now as a surrealist, Matta puns on the word and calls himself a *realista del sur* (a realist from the South), a reference to Chile's location at the southern tip of South America.*

• Carlos Mérida

Born in Guatemala in 1891, Carlos Mérida lived in Mexico most of his life. His father was a pure Maya Indian and his mother was a Zapotec. With that background, plus one Spanish ancestor, Mérida felt at home in Mexico.

As a child he was a gifted musician, but when illness left him partially deaf, Mérida turned to painting. In his later years he often spoke of his paintings in musical terms and gave them musical titles.

At seventeen he went to Paris to study the new art movements and came to know Picasso, Modigliani and others who later became famous. After four years of travel and study in Spain, Belgium and Holland, he came home to Mexico.

His journeys and studies in Europe excited his interest in the ancient art and folklore of his own people. Eventually he began to use motifs from pre–Columbian art in his own paintings. Until that time, only the archaelogists were aware of the rich culture that existed in Latin America before the Spanish Conquest. Mérida's work opened the way for all people to appreciate the heritage left by the early Indian civilizations.

By combining his pre–Columbian heritage with the cubist techniques he had learned in Europe, Mérida made a special contribution to contemporary art. His work is characterized by its abstraction, the rhythm of its color and movement, and the clarity of its structure.

Besides easel painting, Mérida took part in Mexico's mural movement in the 1920s. He assisted Diego Rivera in the first mural Rivera painted in the National Preparatory School in Mexico City, and then painted his own first mural on the walls of the Children's Library in the Ministry of Education.

*Leopoldo Castedo, *History of Latin American Art and Architecture*, 1969.

In the 1960s, working closely with modern architects, he designed murals in Venetian mosaic and copper enamel for buildings in Guatemala.

Residing in Mexico City, Carlos Mérida continued to create drawings, paintings and prints until his death in 1984, at the age of ninety-three. Over the years his art has been exhibited throughout Europe and the Americas, and is owned by public and private collectors all over the world.

• Pablo O'Higgins

Born in the United States, Pablo O'Higgins made his home in Mexico from the time he was a young art student. While he was quite young, his family moved from Salt Lake City, Utah, where he was born in 1904, to a farm in El Cajón Valley, California, where he grew up among Mexican children and learned to speak Spanish. A friend with whom he studied art in a small school in San Diego asked O'Higgins to accompany him to Mexico to visit his family. That was in 1924, a turning point in his life.

During the visit to his friend's family, O'Higgins read a magazine article about murals being painted by Diego Rivera. Impressed by what he read, he wrote to Rivera, who sent a prompt reply and invited him to Mexico City to see the work firsthand. When he visited the older artist in his studio, O'Higgins was invited to work with him on the murals.

Although Rivera had been carefully trained in art academies from the time he was a child of nine or ten, his advice to the young student was not to return to school. He suggested that O'Higgins study art on his own. He thought it especially important for him to explore the ancient Indian art shown at the archaeological museum in Mexico City. Not only did Pablo O'Higgins follow that advice, but he spent time in the streets of Mexico, studying the people and talking to them.

For many years his studio and home were in an old section of Mexico City, among the working people whom he came to know and love, and who often were the subject of his paintings. Just as important to O'Higgins were the *campesinos* (peasants) from outlying rural villages. The artist was a familiar figure in Indian pueblos, where he painted the people and their way of life with sympathy and understanding.

Sometimes working alone, sometimes with other artists, O'Higgins executed many famous murals in Mexico, illustrating such social problems as child labor and unsafe or unfair labor conditions. He also produced

smaller oil paintings, lithographs and woodcuts. Teaching at Mexico's National School of Painting and Sculpture (La Esmeralda), he influenced many younger artists.

In recognition of his skill and understanding of the country and its people, the Mexican government has included works by O'Higgins in all important national art exhibitions. His death in 1983 was mourned by many. Paintings and prints by Pablo O'Higgins have been shown in a number of countries and are owned by museums and collectors in the Americas and Europe.

• José Clemente Orozco

To José Clemente Orozco, art was a way of revealing truth about life. He used his art as a powerful weapon to attack the cruelty of people. Social leaders, war heroes, heads of government, political figures – none escaped his criticism if he thought they were dishonest or acting against the needs of the people. Unlike the other major muralists of his time, Orozco did not ally himself with any political philosophy. To do so, he felt, was to be less of an artist.

Born in the Mexican farming village of Zapotlán, Jalisco, in 1883, José and his parents moved to Mexico City a few years later. At seven he asked to study art and was enrolled in evening drawing classes at San Carlos Academy. To please his parents, however, he studied agriculture and architecture for several years.

An accident in his youth helped change Orozco's mind about his career. An explosion during a chemistry experiment caused the loss of his left hand, an injury to his right hand and impaired vision in one eye. Perhaps the severity of the accident made him appreciate the gift of life remaining to him. Instead of being discouraged by the new handicaps, Orozco decided to devote himself to the work he had always loved best. He returned to San Carlos Academy to study art seriously. When he had learned all he could at the academy, he turned to the street for inspiration and painted the life around him.

His interest in everyday life probably had been aroused first by a famous Mexican printmaker, José Guadalupe Posada, when Orozco was a young primary student passing the printmaker's workshop on his way to and from school. At first he studied Posada's etchings and engravings in the window. When he felt bolder, he entered the shop to watch the artist

at work. He was fascinated with Posada's skill with metal plates, engraving tools and acids, as well as his way of expressing humor or sarcasm in his pictures. Nor did he ever forget how Posada used his art to comment on social problems, such as poverty, disease and crime, or to criticize government action.

Orozco's first experience as a critic occurred when he was attending the art academy and taking part in a strike. Students were objecting to the rigid curriculum and outdated methods of teaching art. Orozco was one of the students who spoke with the Minister of Public Education, and he was successful in getting changes made.

Later Orozco knew what it meant to be on the receiving end of criticism. A mob of students protested a mural of his that condemned the relationship between state and church. The mob threw sticks and stones, rotten eggs and vegetables and destroyed some of his best work. At the time, Orozco was painting the walls of the National Preparatory School in Mexico City. At first discouraged from continuing his work, he later was persuaded to complete the mural.

Before his death in Mexico in 1949, José Clemente Orozco executed many now-famous murals. Some of his most important work was done in the United States between 1927 and 1934, after which he returned to his homeland to live and work. Many younger artists have since been influenced by his bold style and his zeal for social justice.

Easel paintings, drawings, etchings and lithographs by José Clemente Orozco are owned today by museums and private collectors all over the world.

• María Luisa Pacheco

Although María Luisa de Pacheco lived for more than twenty-five years in the United States, her favorite subjects were drawn from the landscape and people of her native Bolivia.

Capturing the luminous light of Bolivia, she painted the colors and textures of the rugged mountain peaks and plains, and portrayed the stoic Indians and their pre–Columbian idols and rituals.

Born in La Paz, Bolivia, in 1919, María Luisa developed skill with paint and brush while quite young, under the influence of her architect father. Her first studio was in the family farm house, where she worked close to nature, inspired by the landscape outside her windows. At the Academy

of Fine Arts in La Paz, she studied sculpture, printmaking and painting.

In 1951 she studied painting in Spain, at the Royal Academy in Madrid, and in the workshop of Daniel Vásquez Días, where she learned to translate light and color into geometric forms. In later years her work became more abstract. She often combined wood or corrugated paper with her paintings, giving them the look of relief sculpture. An architectural quality to her compositions is sometimes attributed to the influence of her father, who died when she was fifteen.

Returning to Bolivia from Spain in 1952, Pacheco taught at the academy in La Paz before coming to the United States in 1956. After arriving in the States, she was given Guggenheim Fellowship Awards three successive times for her painting. Although she made her home in New York City and raised her two children there, she returned regularly to South America to visit with her family and renew her contact with the landscape, the people and the spirit of her native Bolivia.

Many awards were made to Pacheco for her work, which has been shown extensively in North and South America. Public and private collections on both continents include her drawings, paintings and collages.

As a tribute to María Luisa de Pacheco, who died in 1982, the Organization of American States held an exhibition of her work in 1986, at the Museum of Modern Art of Latin America, in Washington, D.C.

• Amelia Peláez

Always a rebel, Cuban-born Amelia Peláez (1897–1968) was unhappy with the old-fashioned art training she received in Havana and New York. A scholarship she won in 1927 sent her to France. Even in Paris, where modern art flourished, she had to search hard to find a teacher who encouraged the kind of freedom of expression she valued. Finally, she chose to study with a Russian woman, Alexandra Extra. The works of such independent artists as Picasso, Juan Gris, Modigliani and Soutine also appealed to the Cuban artist, and her style of painting was influenced by them, too.

Returning to Havana in 1934, she found her modern work was neither understood nor accepted. Cuba's political situation occupied the minds of most people and they generally had little interest in art.

Not discouraged by public indifference, Peláez retired to her home to

work. For subjects to paint, she turned to the plants in her garden and her collection of tropical birds. Objects like porch columns, roofs and iron railings also found their way into her paintings. Except for community drawing classes that she taught in the evening, she lived a quiet life at home with her mother and sisters. Aside from her art, she had a passionate interest in baseball, and followed all the games, knowing every player's name and statistics.

In time, Amelia Peláez was recognized as one of Cuba's finest artists. Painting up to the time of her death, she produced easel paintings, ink drawings and ceramic work, including a number of ceramic tile murals for buildings in Havana, as well as a mural painted in fresco.

Paintings and drawings by Amelia Peláez are owned by museums in Cuba and by public and private collectors throughout the Americas.

• Emilio Pettoruti

This pioneer of modern art in Argentina was the child of Italian immigrants. Born in La Plata, Argentina, in 1892, Emilio Pettoruti showed a talent for drawing at an early age. Teaching himself to paint and to do caricatures with pen and pencil, he won a scholarship in 1913 that gave him a chance to study in Europe.

In Florence, Italy, he learned techniques for painting in fresco, and for making stained glass and stage designs. But he spent most of his time in galleries and museums, studying the drawings of the old Italian masters. He was excited, too, by the work of modern artists, especially the Italian futurists, who stressed movement and speed in their art. By the time Pettoruti had his first one-man show in 1916, in Florence, he was painting in the style of the futurists.

Between 1913 and 1924, Pettoruti traveled through Italy, France Austria and Germany, and met many little-known artists like himself, who later became famous. They befriended one another and exchanged ideas. To earn a living at that time Pettoruti illustrated Italian magazines and designed clothing, ornaments, show windows and stage settings. At the same time he continued to draw and paint in oil and watercolor and to create collages. His work became increasingly abstract and he used both cubist and futurist techniques adapted to his own personal style.

When he returned to Argentina in 1924, Pettoruti found that his countrymen were unprepared for modern art. They were shocked by and

hostile to the strange abstract shapes on his canvases. But he put up a fight for modern art and became its foremost leader and teacher. He wrote articles and lectured on art and on modern teaching and museum methods. His efforts helped educate the public and provided a free atmosphere for young art students to develop.

For many years Pettoruti was director of the art museum in La Plata, and he was the founder and editor of a magazine, *Crónica del Arte*. By special invitation from the United States government, Pettoruti visited that country's leading museums in 1941. This was followed by exhibitions of his work in a number of United States museums.

National and international prizes were awarded to Emilio Pettoruti for his paintings and collages. Today his works are owned by museums and private collectors throughout the Americas and Europe. When he moved to Paris in 1953, he continued to paint and to write, and in 1967, he published his autobiography, *The Painter Facing the Mirror*. Pettoruti died in 1971, in Argentina.

• Candido Portinari

A Brazilian coffee plantation in the state of São Paulo was the birthplace of Candido Portinari in 1903. His parents had emigrated from Italy during their childhoods and had settled on a *fazenda* (coffee plantation) in Brodowski when their son was born. The name of the town had come from earlier Polish immigrants.

Portinari grew up happily among plantation workers who included Italian immigrants and other Brazilian day laborers. Later, out of fond childhood memories, Portinari did a group of paintings known as "The Brodowski Series" or "The Brown Series." The artist chose the color brown to predominate in these paintings because it is the color of coffee, the color of the earth on the coffee plantations and the color of the dark skin of the Brazilian people.

Portinari first handled a brush and paint during his childhood, when he was allowed to help a painter decorate the church in Brodowski. At fifteen, he was apprenticed to an artist in Rio de Janeiro, and three years later he attended his first drawing class in Rio. At twenty-five, he won a scholarship that allowed him to travel to Europe, where he spent most of his time studying the old masters. Returning to Brazil, he discovered his

fellow artists were caught up in a modern art movement, and from then he learned about contemporary art.

Combining what he learned in Europe and in Brazil, Portinari produced a great number of paintings. He used a variety of styles, but his work always reflected the environment of Brazil, particularly its people. His realistic portraits show, almost scientifically, the racial types of the country during his time: Indians, Europeans, Negroes, mulattos and mestizos. Other paintings describe some of the regional differences of Brazil's land and people, including ranchers and the grazing lands of the South; workers on the sugar cane plantations in the Northeast; the coffee plantations of São Paulo; and the community of slum dwellers in Rio de Janeiro.

Before his death in 1962, Candido Portinari had won many awards and was recognized around the world for his easel paintings and murals. In the United States, in addition to murals at the Library of Congress in Washington, D.C., he executed wall paintings for the United Nations headquarters in New York City.

• Omar Rayo

Omar Rayo was born in 1928, in Roldanillo, Valle, Colombia. He taught himself to draw and paint, and by the time he was nineteen, he worked for newspapers and magazines in Bogotá, Colombia, as an illustrator and cartoonist. Humor is still an important part of his art.

At twenty-six, Rayo gave up his job in order to paint and travel through South America. The journey lasted about four years, until 1958, when he returned to Colombia. The following year he won a fellowship to study printmaking in Mexico, where he won awards for his work.

While in Mexico, Rayo began to experiment with a new printing method. By pressing two pieces of cord into paper, he produced a relief print on the other side. When he moved to the United States in 1960, he continued with his printmaking. Rayo thought he had invented his inkless relief printing process, but several other artists, all working alone in New York at the same time, developed the same technique.

Since then, Rayo's paintings and prints have been exhibited throughout the Americas and Europe, and he has been honored with numerous awards. A 1973 award came from his hometown in Colombia and included a piece of land in Roldanillo. As a way of giving back something of value to the city of his birth, Rayo built a unique museum

on the land, the Rayo Museum for Latin American Prints and Drawings, which opened in 1981.

Octagonally shaped, the Rayo Museum suggests the geometric forms found in many of Rayo's paintings and prints. Devoted to works on paper by Latin American artists, it is the only print museum in Latin America. Besides its internal gallery space, the museum incorporates a series of outdoor paintings by many well-known artists assisted by local students. Executed on huge billboards along the highway, the paintings are Rayo's way of bringing art to the people of his home community.

In addition to works shown at the Rayo Museum, paintings, prints and drawings by Omar Rayo are owned by museums and private collectors in many parts of the world.

• Diego Rivera

This famous muralist was born in 1886, in Guanajuato, Mexico. Although he is known today around the world by the simple name of Diego Rivera, he claimed to have been christened Diego María de la Concepción Juan Nepomuceno Estanislao de la Rivera y Barrientos Acosta y Rodríguez.

By the time Rivera was three, he was drawing on everything he could put his hands on, and his father had to line a room with blackboards, mural style, to hold the boy's sketches. Even as a child, Rivera was unable to draw things unless he understood how they were made. Animals, insects, plants, toys—all were carefully studied. Until he understood the inner structure of mountains, which happened much later in life, he was unable to paint them.

The same careful study went into Rivera's mural painting for Mexico's public buildings. Before making his first brush strokes, he pondered all the technical problems of applying paint to Mexican walls. In Italy he studied the fourteenth century fresco paintings by Giotto on the chapel walls of Padua. He experimented, too, with different ways of drawing and painting before deciding on a simple style, one easily understood by the many people at home unable to read.

To better understand the history of his own country, Rivera visited the sites of the old Maya and Aztec civilizations, where the ancient Indian arts developed. During his student days in Mexico he had come to know and love pre-Columbian art.

First trained in Mexico, Rivera spent additional years in Europe, studying, painting and traveling. In 1921, he returned to Mexico to support his people during their Revolution.

Like José Clemente Orozco, his concern for the people had been sparked long before by another famous Mexican artist, José Guadalupe Posada. On his way to and from school, young Rivera had frequently stopped at Posada's studio to watch him work. He noticed that Posada's pictures were based on the life going on around him. Later Rivera said that Posada had taught him the connection between life and art, and the importance of painting out of the depth of one's feelings.

Despite Rivera's dedicated study of the European masters, his own work was Mexican in style, theme and subject. Several generations of artists around the world have been influenced both by his style and his ardor for social justice.

Because of Rivera's confirmed Communist involvements, he and his works were often the center of controversy. But not all his works were political. A prolific artist, he created oil paintings, lithographs and drawings on a variety of subjects, in addition to miles of murals. Most of his murals are in Mexico, but many were done in the United States.

Among his murals in the United States is a group done in Detroit, Michigan, in the 1930s, showing the influence of machines and industry on human beings. In 1986, to celebrate the 100th anniversary of Rivera's birth, a traveling exhibition of his art opened at the Detroit Institute of Art, the site of his industry murals.

On Rivera's death in 1957, his personal collection of pre–Columbian art was given to the Mexican government, and is now housed in the Diego Rivera Museum of Anahuacalli. Works by Rivera belong to private and public collections throughout the world.

• Francisco Rodón

A proud Puerto Rican, Francisco Rodón expresses his deep feelings for his country by painting the land, its plants, its light, its colors, and its people. His fervent hope is to see his countrymen develop a better sense of their own worth and abilities.

Born in 1934, in San Sebastian, Rodón grew up on his parents' tobacco plantation in the mountains of Barranquitas. His family was not happy when he decided to leave school. His two brothers were trained for

professional careers and his parents would have liked the same for Francisco. Even pursuing his chosen career as an artist, Rodón preferred to teach himself. Although he did attend several art schools, it was never for more than few months at a time. At his first art exhibition, he exaggerated the amount of training he received, out of embarrassment. Today he admits with confidence that he taught himself to solve most of the technical problems of painting.

As a young man, Rodón went to New York City for a short time, but he was overwhelmed by the heavy traffic, the rush of people and the impersonal quality of life. He contrasts this experience with a trip he took to South America. On arrival in Buenos Aires, he hired a taxi for a tour of the city. When the driver learned Rodón was a visitor and, besides, an admirer of the popular tango singer Carlos Gardel, he closed the meter of his cab and drove him through the streets and *barrios* at no cost.

For some years Rodón has maintained a studio in San Juan, not far from the University of Puerto Rico, where he is Artist in Residence. Besides painting, he is an avid reader, caught up in the history, literature and politics of his own country and others.

In his studio Rodón works slowly and carefully, usually to a background of music, never allowing himself to be pressured by time or circumstances. Sometimes he works on a single painting for several years, constantly reworking and improving it. For example, the portrait of his niece, Inés (see *Watchful Image*, page 34), was begun in 1970, but he continued to make changes on it during the next five years. Even after it was hung in the living room of Inés's parents, he would add a fresh brush stroke now and then.

Portraiture has become Rodón's forte, and he has painted portraits of many famous people, including writers Jorge Luis Borges and Juan Rulfo and ballerina Alicia Alonso.

Numerous prizes and honors have been awarded to Francisco Rodón for his work. His paintings hang in museums in Puerto Rico, as well as in private collections there and throughout the Americas.

• Julio Rosado del Valle

Painting from nature is what Julio Rosado del Valle loves most. His first inspiration always comes from his own Puerto Rican environment,

illustrated by his many paintings of shells, flowers, leaves, insects and their larvae, and people from his island.

Water was his first love. Born in Cataño, Puerto Rico, in 1922, Rosado remembers building his own boat of zinc and wood. He made a sail from a cloth flour sack and sailed his boat from Cataño to San Juan, across the bay. Rosado is still fond of sailing, and proudly displays in his studio a large model boat he built to scale, including the mast, sails and rigging.

Rosado began to paint as a high school student in Bayamón, and had several exhibitions before enrolling at the University of Puerto Rico on a scholarship. During that period he earned money, first by helping with the bookkeeping in his father's barbershop, then by working as a chemist's aide in a cement factory.

Another scholarship gave him a chance to study art in New York for two years. Afterwards he traveled to France and Italy, where he was awed by the work of the great masters, particularly Michelangelo's *Slaves* and *Pietà*. During a later trip to Spain, he was overwhelmed by the power of Goya's art, especially the series describing the disasters of war; and in Barcelona, the modern church designed by Antonio Gaudí, the Expiatory Church of the Holy Family, inspired the sculpture Rosado constructed on his return to Puerto Rico.

Today Julio Rosado del Valle works in a studio in San Juan, not far from the University of Puerto Rico, where he is Artist in Residence. There have been a number of awards for his art, which includes murals as well as easel paintings and sculpture. His work has been shown in numerous countries and is part of many public and private collections.

• Lotte Schulz

Although she was born in Paraguay and makes her home there today, Lotte (Carlotta) Schulz grew up in Brazil. She was born in Encarnación, Paraguay, in 1925, of an Austro-Hungarian father and a Spanish-French mother with long ties to Paraguay. When Lotte was four years old, she was taken by her family to Brazil.

At twenty-two, she returned to Paraguay, but it was another ten years before she made the decision to enter the art world as a professional painter. Marriage and raising a child occupied her earlier years. Winning an award at a religious art show in Asunción, Paraguay, helped Lotte make up her mind about her career. Shortly afterwards she began to exhibit

paintings and sculpture at art shows and competitions in other cities and other countries.

In 1965, she was invited by the government of the United States to visit the country's leading museums and galleries. In 1972, she was awarded a fellowship by the Italian government to study techniques of conservation and restoration of fine art. While studying in Rome and Florence among Italy's Renaissance masterpieces, she was particularly moved by the sculpture of Michelangelo. On her return to Paraguay in 1974, she began important restoration and conservation efforts in Paraguay's Museum of Fine Arts.

A self-taught artist, Lotte Schulz has been winning awards for her work since her earliest exhibitions. Her paintings, sculpture and engravings have been shown in Lugano, Tokyo, Madrid, and Botswana, as well as in South American cities.

When not traveling with her engineer husband on work trips around the world, she makes her home in Puerto Presidente Stroessner, Paraguay. Their remote section of the country abounds in wild orchids and exotic birds and fish. With its old Spanish architecture and native embroidery, weaving and ceramics, Paraguay offers much to stimulate the eye of an artist.

Despite Lotte Schulz's love for the monumental figurative art of Italy, she works in a contemporary abstract style when free to pursue her own personal art.

• Lasar Segall

Brazil is the adopted country of Lasar Segall, who is credited with being a forerunner of that country's modern art. Born in Vilna, Russia, in 1891, he made his first trip to South America in 1912. Before that he had lived and studied art in Germany and Holland and had begun to exhibit his paintings with the German expressionists, a group of artists who distorted and exaggerated figures and forms in order to express strong feelings.

Segall's need to express strong feelings began in his youth, when he saw great suffering among the poor and hungry people of his native Vilna. Later, as a young man in Amsterdam, he witnessed the misery of the inmates of Almshouse. Not long afterwards, on the way to Hamburg,

Germany, by boat, he observed human beings "stowed away like cargo."* His despair deepened at so much wretchedness, and he found relief by expressing himself in the jagged distortions of his art.

At twenty-one, Segall set out for South America, looking for new experiences and new views of life. When he arrived in Brazil, he fell in love with its natural beauty, its dense forests and foliage, its brilliant light and rich colors. More than that, he was fascinated by Brazil's mixture of people—the native-born, the immigrants from around the world, and the Negroes, who had come as slaves and recently found freedom. Everyone seemed to be working with hope and trust to develop the still-unformed country.

While in São Paulo and Campinas, the artist exhibited some of his paintings. This was Brazil's first exposure to modern art, and in 1913 most Brazilians could not understand Segall's distorted figures with their exaggerated heads. But his paintings inspired a few Brazilian artists to travel to Berlin and Paris to study the modern movements.

Lasar Segall returned to Germany and, when World War I broke out in 1914, he was interned as a war prisoner because of his Russian citizenship. After two years of exile, he was allowed to return to Dresden, and once again he joined the German expressionist painters. He exhibited frequently with them and had one-man shows of his own. Segall's work differed from the other expressionists in the compassion he showed toward the people he painted.

Despite the success and honors he met with in Germany, Segall was drawn back to Brazil. In 1923, he settled in São Paulo, married a Brazilian woman, and became a naturalized citizen. Continuing to grow and develop as an artist, he sometimes influenced his fellow Brazilian artists; at other times they influenced him. By 1930 he had become one of the country's leading artists. Together with Candido Portinari and Emiliano Di Cavalcanti, Lasar Segall has been recognized as a pioneer of modern art in Brazil.

The land and people of Brazil provided Segall with endless subjects for drawing, painting, sculpting and etching. With the passage of time, the angular cubism of his earlier works became softened and more classical.

Although the Brazilian environment made a great impact on his work, he never forgot the suffering of the Jews of his native Vilna and the other Europeans uprooted during the two World Wars. Many of Segall's

*P.M. Bardi, *Lasar Segall*, 1959.

paintings were devoted to the tragedies of the Jewish people, but he was equally sensitive to the suffering, physical and psychological, of the people around him in Brazil.

After Lasar Segall's death in 1957, a museum was established in São Paulo dedicated to his art and memory. Works by him are also part of public and private collections around the world.

• Guillermo Silva Santamaría

Little is known about the personal life of Guillermo Silva Santamaría. Born in Bogotá, Colombia, in 1921, he attended art school there, and later studied in the United States, France and Mexico.

In France in the 1940s, he learned to make stained glass, and the way Silva Santamaría uses precise lines and jewel-like colors in his printmaking reflects his glassmaking skill. Later he helped to establish Colombia's first stained glass workshop.

Another influence on his art was his first trip to Peru, in 1953, when he visited Machu Picchu, the ancient city of the Incas. After studying the abstract art of the ancient Peruvian Indians, he changed his own style of painting from realism to abstraction.

For a while Guillermo Silva Santamaría lived and taught printmaking in Mexico City, where he was a member of a group that helped organize the Museum of Modern Art there. Since then he has lived and worked in various other countries.

• David Alfaro Siqueiros

As much a man of politics as an artist, José David Alfaro Siqueiros spent his life fighting for the rights of working people. He fought with words and with guns, as well as with his paintings.

Siqueiros was born in 1896, in Chihuahua, Mexico. When he was two, his mother died, and he was sent to Guanajuato to live with his grandparents. Perhaps it was there he first learned to care about the problems of the people, since his grandfather had been a *guerrillero* (guerrilla leader) in the army of Benito Juárez, a hero of the people.

At eleven, Siqueiros returned to his father's custody in Mexico City. He attended art classes at San Carlos Academy, was involved in a student strike and, at fifteen, received a jail sentence for his part in a violent demonstration. This was the first of many imprisonments arising from the free and fiery expression of his ideas.

His father's severely religious home was an unhappy place for young José David. During the Mexican Revolution, the Constitutional Army camped close to the Siqueiros home, and the youth ran off with the army as their sixteen-year-old drummer boy. Later he was made a captain and sent to Madrid and Paris as military attaché for his country. While in Europe, he combined his military duties with the study of modern art.

In Paris he met his countryman and fellow artist Diego Rivera and other European political thinkers and artists. They had frequent, heated discussions about how to develop a revolutionary new art that would communicate social ideas to the masses of people unable to read. They wanted to use their art to improve living and working conditions for the poor. For the Mexican artists, mural painting was the answer. While still in Paris, Siqueiros wrote the first of many passionate articles about art and politics.

Returning to Mexico in 1922, he organized a union for painters and sculptors and executed his first murals at the National Preparatory School in Mexico City. At Guadalajara he painted murals at the university, organized a union for miners in the state of Jalisco, and edited a Communist newspaper at the same time. In 1935, he went to Spain and fought in their Civil War, in support of the Popular Spanish Army.

At home and abroad, his extreme political views and his emotional nature often got him into trouble. But neither imprisonment nor the threat of exile could stop him from writing, painting and speaking his mind openly.

Most of his murals are in Mexico, but others exist in the United States, South America and Europe. In 1972, a gigantic mural, *The March of Humanity*, was unveiled at the Siqueiros Cultural Polyforum, a new and dramatic building designed by Siqueiros in Mexico City.

At the time of his death in 1974, he was working on a mural begun some years earlier in the Customs House of Santo Domingo, in Mexico City. Smaller easel paintings and lithographs by David Alfaro Siqueiros are owned today by museums and private collectors throughout the world.

• Juan Soriano

Born in Guadalajara in 1920, Juan Soriano seems to have inherited his mother's lively wit. When he spoke of his father joining the Mexican Revolution of 1910 as a soldier, Soriano claimed his mother joined the Revolution as a *soldadora*, a pun on the words *soldado* (soldier), *soldadera* (camp follower) and *soldador* (solderer). His mother raised her children in a creative way, sometimes organizing them into a circus troupe or into a union of artists. Soriano says he had four sisters and thirteen maiden aunts, but since he is known for his vivid imagination, his statements are not always reliable.*

It is known that Soriano had only a few years of primary schooling, and that at thirteen he began to paint, teaching himself what he could. He preferred landscapes and portraits of children, rendering them in a realistic style. While still in his teens, he had his first exhibition in Mexico City, where his talent was quickly recognized. But he did not study art seriously until he was twenty-three, when he began working in the studios of several mature artists. The *retablos* he painted and the colonial art he copied encouraged him to draw and paint in a realistic way.

After traveling in the United States and Europe, he worked and studied in Rome for several years. On his return to Mexico, he began to paint in a new, imaginative style. Although his work became abstract, he never gave up realistic forms completely. In a single painting he can combine abstraction and realism, as illustrated in *The Bicycle Circuit at France* (see color insert).

Besides easel painting, Juan Soriano has created set designs for plays and ballets, illustrations for books, and sculpture in both ceramic and wood.

• Jesús-Rafael Soto

Both Jesús-Rafael Soto and the city of his birth, Ciudad Bolívar, in Venezuela, have come a long way since 1923, the year of Soto's birth. Growing up there, he saw no art at all, nor did he ever see an easel. Today Soto is a world-famous artist, and Ciudad Bolívar is the location of a large modern art museum established by him. The Jesús Soto Museum is

*Virginia Stewart, *45 Contemporary Mexican Artists*, 1951, p. 145.

devoted to contemporary art by artists from Venezuela, other North and South American countries, and Europe.

When Soto finished primary school, he worked in his native city painting movie posters. A scholarship took him to Caracas, Venezuela, to study art. At that time the teachers had been trained mainly from art books and magazines, and few understood the important twentieth century art movements that had taken place in Europe. In spite of their limitations, they were able to instill in their students an enthusiasm for learning and experimenting.

Eager to understand cubism better, Soto left Venezuela in 1950, for Paris, where the movement had been invented about forty years earlier by Georges Braque and Pablo Picasso. Although Soto did not know a word of French, he borrowed books from friends and, with the help of a dictionary, spent his first three months in Paris reading about cubism and all the movements that followed.

Next he sought the galleries and studios where he could see original works of art and meet their creators. He had long discussions with the artists, and when he thoroughly understood every art movement, Soto felt ready to develop in his own direction. To earn a living during his early years in Paris, he sang Latin American folk songs and played his guitar in Left Bank nightclubs.

In finding his own direction, Soto was influenced by the work of the Dutch modernist Piet Mondrian, and the American Alexander Calder. He set out to create an art form combining the abstract, geometric shapes of Mondrian's paintings with the movement in Calder's mobile sculpture. Years of careful work brought him to his goal. In Soto's work, the vision of man is the motor that creates its movement. (See *Interfering Parallels Black and White*, page 58.)

After his early experiments, Soto began to use thread, wire, nails and metal rods to convey the idea of movement through vibration. Shadows and reflections, as well as the movement of the spectator, play an important role in his work.

Soto's inventive paintings and sculptures were among the first to force the viewer to participate in a work of art. His concept of color is also unique. He feels that a work of art is altered by the colors of the environment in which it is viewed, as well as by the elements of space, light and time.

Married to a Parisienne, and the father of four children, Soto divides his time between Paris and Caracas. In his fourth-floor walk-up studio in

Paris, described by one writer as resembling a carpenter's shop, he works all day, stopping only for lunch and some guitar playing.

Jesús-Rafael Soto has received many awards and honors for his work. His paintings and sculpture belong to private collectors and museums around the world.

• Fernando de Szyszlo

Opposite cultures were brought together when Fernando de Szyszlo was born in 1925 in Lima, Peru. His mother was Peruvian, of Spanish-Indian descent, and his father was a geographer from Poland. Later, when Szyszlo became a professional artist, he again brought together two opposites – a modern art style and an ancient Indian heritage.

His first art education was at the Catholic University in Lima, where he became a realistic figure painter. After studying in Europe, he turned to abstract painting. For him there was no conflict in using a modern style to express his feelings for the pre–Columbian heritage of his Inca ancestors.

Peru's ancient textiles, ceramics, ruined cities and temples, language, legends and history are the subjects of Szyszlo's work. He does not portray these things precisely and realistically. Instead, he expresses the strong emotions they arouse in him by painting strong forms in natural colors and textures. His abstract expressionist style of painting is sometimes called abstract nativism. It is influenced as much by his Slavic temperament as by his identity with the ancient Peruvian culture.

One of his favorite places is the reconstructed Inca palace, Puruchuco, near Lima, where he has often taken his two sons. He loves its earthy quality and its sense of ongoing history. Another source of inspiration is the ancient city of Machu Picchu, in Peru.

When Szyszlo's first abstract paintings were shown in 1950, they were angrily criticized, and called decadent and un–Peruvian. In time, however, people grew to understand the artist's work and to associate his colors, textures and forms with their pre–Columbian past.

Szyszlo wants to see improvement in the economic and social conditions of his people, but he is not a politician. Painting is the tool he uses to show concern for his country's future.

After spending several years working and teaching in the United States, Szyszlo is back in Lima. He paints in a small hideaway studio to the

accompaniment of classical music. He works slowly, covering opaque colors with transparent colors, and waiting for each layer to dry. Often he uses a computer to decide the best perspective to follow.

Fernando de Szyszlo takes pleasure in knowing that many of his paintings are owned by Peruvians and other Latin Americans. Works by him are also owned by North Americans and by public museums throughout the hemisphere.

• Rufino Tamayo

Vivid memories of growing up in Mexico give Rufino Tamayo's paintings their rich Mexican spirit. Although he has traveled to far-off places and has lived for long periods of time in New York, he has always considered Mexico his home, returning often to renew contact with his native country. He is proud to be a Mexican, but he considers himself a universal man, the product of all his experiences. And man, as a universal symbol, has become the center of his work.

Tamayo was born in 1899, in Oaxaca. His olive-colored skin and blunt features reflect the heritage of his Zapotec Indian parents. Some of his earliest recollections are of the colorful costumes of the native Zapotec and Tehuantepec people. At the death of his parents, when he was still a child, he moved to Mexico City to live with an aunt and work after school in her fruit stall at La Merced, an open-air market. The tropical fruits he sold were heaped in colorful pyramids, and he carried away with him lasting impressions of their shapes, colors and textures.

Popular folk art and pre–Columbian art also interested him and influenced his work. He began to understand and love the ancient Indian art in his early twenties, when he was in charge of the anthropology museum in Mexico City. In the years that followed he developed his own collection of ancient sculpture. In 1974, on their fortieth wedding anniversary, the artist and his wife presented their thousand-piece collection to the city of Oaxaca.

In the 1920s, while the Mexican muralists were painting the walls of public buildings, Tamayo was teaching school. Although he painted several murals, he was more interested in easel work. He believed the large size of murals made them suitable for describing history and current events, or for telling a story. But he thought that easel paintings, because of their smaller size, were better able to describe psychological qualities,

expressed through subtle colors and interesting shapes and textures, reflecting Mexico in another way. (See *Watermelon*, in the color insert.)

Going to New York in 1938, Tamayo came in contact with important American and European artists and was strongly influenced by an exhibition of Picasso's work. Without losing its Mexican qualities, his work began to take on universal meaning, something that people anywhere could understand. During the winters Tamayo would paint and teach in New York, returning each summer to Mexico. In this way he kept in touch with the people and atmosphere of his own country.

In 1981, Tamayo helped open a new museum in Mexico City, built to hold his own collection of postwar European and Latin American art—his gift to his country. With no children of his own, Tamayo wanted to present his art collection to the Mexican people, to help them grow into the future.

World-famous now, Tamayo's work is owned by museums and collectors throughout the world. Today he stays at home in Mexico City, working from early morning to dark each day, in a studio opening onto a garden decorated with ancient Mexican sculpture. Here Rufino Tamayo has all the things he loves—the earth, the art, the mood of Mexico.

Joaquín Torres-García

When Joaquín Torres-García was seventeen, he moved with his family from Montevideo, Uruguay, where he was born in 1874, to Spain, the country of his father's birth. He studied art in Barcelona, met Picasso and other artists and learned about French and Spanish modern painting. The old Spanish and Italian masters engrossed him, too, and he studied ancient Greek art as well. Later he concentrated on the contemporary Dutch artist Piet Mondrian. Eventually, all these influences were absorbed into Torres-García's own unique contemporary style.

His varied skills are reflected in the church murals he painted in Barcelona and the stained glass windows he worked on at the Cathedral of Palma de Mallorca. For the World's Fair in Brussels in 1910, he painted panels for the Uruguayan Pavilion, and later he did murals for the Spanish government.

When he was forty-six, Torres-García left Spain and sailed to the United States with his wife and children. New York's lively movement and atmosphere became the new subjects of his paintings, but in the early

1920s, New Yorkers were not interested in buying modern art. Unable to earn a living by painting, he turned to creating background scenery for the theater, and selling mechanical toys he made. But two years of poverty forced him to return to Europe.

In Paris, he enjoyed a bit of prosperity. By this time he had already formed his mature, geometric style of painting, and he associated with artists who worked in a similar way. Among them were Mondrian, Kandinsky, Seuphor, van Doesburg and Vantongerloo, all of whom later became famous. Unlike these abstractionists, Torres-García always kept objects recognizable in his paintings. A simple, natural person, he created a simple, nature-based art that could be easily understood by people everywhere. He called his own work "universal constructivism."

Many people see in Torres-García's work the symbolism used by early South American Indians, as well as the grid structure of Inca buildings in Peru. It was in Europe, in 1930, that Torres-García saw ancient art from his own hemisphere for the first time, and his work soon began to reflect its influence. His colors became more earthy and his patterns more abstract.

Seeing the pre–Columbian sculpture filled him with a longing for his homeland, and in 1934, he returned to his native Uruguay, and established his home in Montevideo. The teaching workshop he established later attracted artists from Europe and throughout the Americas.

He wrote several books about his theories, and even after his death in 1949, his strong influence continued to be felt through his writings, his paintings and his teachings. Thirty-eight years after his death, a large exhibition of his work traveled to major cities in Europe and the United States.

Awarded the Grand National Prize for Painting in 1944 by the government of Uruguay, Joaquín Torres-García is still considered one of Latin America's most outstanding artists. His works hang in museums and private collections throughout Europe and the Americas.

• José Antonio Velásquez

Not trained as an artist, José Antonio Velásquez spent most of his life doing other things. As a young man he was a field worker and dock hand on the northern coast of Honduras. Later he became a telegraph operator and barber, and then the mayor of his town.

Born in 1906, in the village of Caridad, Velásquez showed an early talent for drawing and painting. A throat illness in childhood left him with damaged vocal chords, perhaps sharpening the need to express himself in ways other than words.

At twenty-four, Velásquez moved to San Antonio de Oriente, where he married and began his family of six children, many of whom became painters, also. In the early days, between his jobs as telegraph operator and barber, he would find time to slip away to the mountains to paint.

While Velásquez worked as a barber for an agricultural school near Tegucigalpa, the school's director encouraged his painting, and helped sell his work. Visitors to the school often purchased his pictures and took them to North America and elsewhere, helping to spread his reputation.

Without formal training and unconcerned with working out the technical problems of painting, Velásquez set down on canvas what his eye saw. His way of painting is known as *naive* or *primitive* art.

His work reflects the rich color and light of Honduras and captures the landscape and the life of his village. A town of fewer than two hundred residents, San Antonio de Oriente is built into the mountains. Its old Spanish church, the tree-studded hills, the gardens, the people and their farm animals all find their way into paintings by Velásquez.

One of his paintings represented Honduras in an art show that traveled through the Americas in 1949. Two years later his work was shown in Madrid, Spain, in a special Spanish-American art exhibition. In 1954 Velásquez left Honduras for the first time, to come to the United States for an exhibition of his work in Washington, D.C. Not long afterwards, he gave up barbering and telegraph work to paint full time.

Since then the work of Velásquez has been exhibited throughout Latin America and in several European countries. Honored by his village and his country for his art, and world-famous, he never ceased to be amazed that people paid for work he did out of pure love. Until his death in 1983, in his late seventies, José Antonio Velásquez continued to paint new scenes of the village he loved, working six days a week, from dawn to dusk, stopping only for a siesta at midday.

• Francisco Zúñiga

When Francisco Zúñiga begins a new work of art, his inspiration often starts with something he notices by chance—the way an emotion is

expressed, or the way a woman looks when she is wrapped in thought or walking or leading a child. It is never exact anatomy that he wants to capture, but an overall shape, the space around it and the play of light and shadow. Mainly, Zúñiga is a sculptor, and even when he draws or paints, his figures have the three-dimensional quality of sculpture.

Zúñiga was born in 1912, in San José, Costa Rica, of a Spanish father and a mestiza mother. His father, a sculptor of religious images, was Zúñiga's first teacher, sharing woodcarving techniques with him, as well as color theories as they mixed mineral soils in their studio. Later he studied at the School of Fine Arts in Costa Rica.

At thirteen, Francisco was carving from wood, using his mother and sisters as models. At twenty-three, he won first prize for a stone statue, larger than life-sized, called *Motherhood*. It created a controversy in San José, where it was considered too modern. Although Zúñiga had read avidly of the modern art movements in Europe, his style also had been influenced by the ancient sculpture of the Chorotega and Guetaro Indians of Costa Rica. *Motherhood* had combined modern and ancient qualities.

Having read about the pre–Columbian art and architecture of Mexico, as well as its contemporary mural art, Zúñiga found his way to that country in 1936. There he worked with established sculptors, continued to study drawing and painting, and explored the Indian art. He was impressed with the Indian themes of life and death, the strength of the figures and the religious feeling expressed by the ancient artists.

Today Zúñiga's works have many of the same qualities as the old Indian art. His figures are strong, solid and heroic. In addition to pre–Columbian influences, Zúñiga's art shows his understanding of the modern sculptors Barlach, Rodin, Maillol and Brancusi. Whether on paper or executed in bronze or stone, his works reflect the dignity of working people, their confidence and their optimism.

A devoted family man, Zúñiga lives in Mexico City, with his Mexican wife and children. Two studios in his residence provide work space for him, and another studio in Cuernavaca gives him a chance to enjoy the country atmosphere.

Numerous awards have been given to Francisco Zúñiga. His sculpture can be seen in many public places in Mexico and Costa Rica, and works by him are owned by museums and private collectors throughout the world.

Glossary

abstract art. Art in which the natural appearance of a form is changed by the artist to create an imaginative appearance. Sometimes the original form can be recognized, sometimes it cannot. In Pettoruti's *Intimacy* (page 37), the original forms can be recognized. In Szyszlo's *Huanacaúri* (see color insert), the original forms are not recognizable. (*See also* **nonobjective art.**)

abstract expressionism. An abstract art style in which the artist expresses strong personal feelings, sometimes through vigorous brush strokes and paint texture (see Forner's *Astrofish*, page 47), and sometimes through bold colors.

acrylic paint. A synthetic paint which can be thinned with water. Also called acrylic resin paint.

altarpiece. Art used to decorate an altar for religious purposes.

ancient art. In Latin American history, ancient art refers to indigenous art created before the arrival of Christopher Columbus to the New World. (*See also* **pre-Columbian art.**)

atelier. A workshop or an artist's studio.

canvas. A heavy, closely woven cloth on which oil paintings are usually made.

caricature. A comic drawing or a drawing in which certain features are exaggerated for humor or satire.

cartón. An absorbent cardboard upon which the use of oil paint produces a heavy, rich surface.

ceramics. The art or technique of making objects from baked clay. Also, objects made of fired clay.

collage. The application of paper and other materials, basically flat, to form a part or whole of a picture.

composition. The way in which the basic elements are organized in a work of art.

constructivism. An art style used by both sculptors and painters. In painting, artists reduce objects to basic geometric shapes and lines. Joaquín Torres-García (see his painting called *Constructivism*, page 28) was unique as a constructivist in that he kept the objects of his paintings recognizable. He called his style "universal constructivism."

contour. The outline of a form. It can be an actual line or the illusion of a line that contains a shape.

cubism. A style of art in which the artist changes natural forms into geometric shapes: cubes, squares, ovals, rectangles, triangles, circles, etc. (See Mérida's *City Landscape*, page 26, and Pettoruti's *Intimacy*, page 37.) Sometimes an artist breaks down a form into many small geometric shapes and then reorganizes the form, with the small shapes overlapping.

design. The way in which the basic elements are organized in a whole work of art or in a part of it. Also, a term applied to the form of useful objects.

earth colors. Colors that are associated with the earth; that come from pigments found in the earth; that are derived from plants, animals or minerals.

easel. A support for a small or medium-sized picture, used by an artist while painting.

easel painting. Pictures small enough to be supported by an easel, as opposed to wall-sized pictures or murals.

elements (of art). The basic parts that the artist organizes into a work of art. These include line, shape, space, light, color and texture.

engraving. A printing process in which a wood or metal surface is used. A sharp tool, used directly on the surface, forces deep grooves in the material, to hold the ink for printing. The finished print usually has crisp and bold lines.

etching. A printing process in which a metal plate is used. The plate is

first covered with a layer of wax. Special etching needles or other tools are used to draw the picture onto the waxed plate, which is then dipped into acid. The lines drawn with the etching needle are bitten by the acid. They form grooves that hold the ink when the plate is ready to print. (Modern artists often press other substances into the soft surface of the plate to achieve interesting textures and patterns.)

expressionism. An art style in which the expression of the artist's personal emotions is most important. This usually results in distorted and exaggerated lines and shapes. (See Guayasamín's *Desperation*, page 86.) In modern art, expressionism is associated with movements that developed in Germany in the early twentieth century.

figurative art. Art which involves the human figure. It can be realistic or partly abstract. (See Soriano's *Bicycle Circuit at France*, in the color insert, and Lasansky's *Birth*, page 70.)

fine art. Art intended solely to enrich the viewer's spirit, rather than to serve some functional or practical purpose.

folk art. Art made by people who are not professionally trained. It can be in the form of useful objects or decoration. Sometimes known as popular art. (See background objects in Rivera's *Studio of Diego Rivera*, page 10.)

form. The shape of an object. It can be realistic, recognizable or completely abstract.

fresco. The technique of painting on moist lime plaster with water-based pigments.

futurism. A movement in which artists represented motion and speed in their work. Began in Italy in 1910.

geometric forms. In art, these are forms that suggest mathematical lines, shapes and angles, such as squares, arcs, circles, cubes, triangles, and the like. (See Rayo's *Last Light*, page 15.)

German expressionism *see* **expressionism**

gouache. A form of watercolor paint based on pigments that create dense color, as opposed to transparent color.

graphic art. Any art form in which lines and strokes are applied to a flat surface. This includes drawing, engraving, etching, lithography and other processes where the picture can be reproduced.

intaglio. This is one of the major categories of printmaking techniques. It includes any process where the printing surface is incised, or grooved, as opposed to a relief process, where the printing surface is raised. Intaglio plates are inked and the top surface is then wiped clean, leaving ink only in the grooved areas. By running the plate through a press, the ink is transferred to damp paper.

lithography. A printing process where the artist draws directly on a stone or metal plate with a greasy crayon. The stone is then wetted and coated with an oily ink. The ink clings to the greasy area and is repelled by the wet areas, which will be left blank in printing. Dampened paper is laid on the stone, and together they are run through a press, which transfers the inked portion of the stone to the paper.

masonite. A board made from pressed wood fibers.

medium (plural, *media*). The particular material used on the surface of a work of art to create the image: oil paint, watercolor, pen and ink, chalk, etc.

mixed media. The combining of materials in a work of art, such as wood, metal, plastics, cloth or any other matter added to the surface of a painted work.

mobile. Sculpture with moving parts set in motion by air currents.

mosaic. The process of imbedding small bits of ceramic, glass, marble, or other hard, colored materials into cement.

mural painting. A picture that is painted directly on a wall, or a large painting that is fastened to a wall.

nonobjective art. A general term which includes abstraction, abstract expressionism and a variety of other art styles where forms are imaginative rather than realistic. (See Matta's untitled etching, page 9.)

oil paint. A paint made with ground pigment and a drying oil.

op art. An art form that relies on optical illusions and creates visual and

psychological responses in the observer. Generally, it involves contrasting colors or a mass of shapes and lines that seem to shift as the eye tries to separate the background and the foreground. (See Soto's *Interfering Parallels*, page 58.)

optical art *see* **op art**

palette. The surface on which an artist sets out his colors or mixes them. The term also refers to the range of colors an artist uses.

pastel, pastel drawing. A drawing made with crayons formed of colored powders mixed with chalk, water and gum.

perspective. A term used to describe the illusion of depth created by the artist on a flat surface, to make things appear as they do in nature. (See Chapter 3, "Space.")

pietà. An image of the Virgin Mary holding the body of the dead Christ.

pigment. The coloring matter, usually in powdered form, that is mixed with liquid (such as oil or water) to make paint.

Plaka. A commercial name for a paint made in Germany.

pop art. A movement in which artists choose their subject from popular culture and the commercial world. They depict in a very realistic way such things as soup cans, coke bottles, movie stars and comic strips.

pre–Columbian art. The indigenous art of the Americas before the arrival of Columbus to the New World.

primary colors. Red, yellow and blue. These colors, when mixed in different combinations, can produce all other colors, but they cannot themselves be produced by any combination of colors.

print. A work of art made by impressing paper or cloth to any block or plate worked for the purpose of printing. Most blocks and plates can produce many prints. *(See also* **engraving, etching, intaglio, lithography, relief print, silk screen.***)*

printmaking *see* **print**

realism. An art style in which the natural appearance of an object or figure can be easily recognized. (See O'Higgins's *Breakfast*, page 20.)

relief print. A print made from a process opposite to intaglio. Instead of incising lines or grooves below the surface of the block, the artist cuts away the surface where the print is to be blank. The raised portions that remain hold the ink that is transferred to paper or cloth in the printing process. When more than one color is used, separate blocks are needed for each color. Rather than cut away the surface, some modern artists use adaptable materials to build up the areas that will form the design.

Renaissance. A period in European history, largely the fourteenth and fifteenth centuries. It represented a time of great interest in all the arts, history, knowledge, the importance of the individual, and the physical world. In the art world, detailed realism was at a high point. The Renaissance started in Italy with the paintings of Giotto and ended with great developments through the work of Michelangelo, Raphael and Leonardo da Vinci.

representational art. A style of art where objects and figures are depicted in their natural forms, as opposed to abstract forms. (See Velásquez's *San Antonio de Oriente*, page 24.)

serigraphy *see* **silk screen**

silk screen. A process for reproducing color prints by the use of stencils and a silk-covered frame. Paint is squeezed through a separate silk screen for each color, while a solid stencil keeps paint away from the portion not to be colored. Also known as *serigraphy*.

stained glass. Glass that is given color by adding pigments or metal oxides during the glassmaking process. Sections of colored glass are joined by lead strips to form a picture or design. Used often in church windows.

still life. A painting or drawing of inanimate objects, such as pottery, fruit, flowers, etc. (See Rodón's *Wild Mushrooms*, in the color insert.)

style. The way in which an artist expresses himself in his or her work. Also used to describe a special characteristic of a given period in art history.

stylize. To use unnatural lines and shapes to represent a form, in order to stress the design quality of a figure or object. (See Silva Santamaría's *Fallen Knight*, in the color insert.)

surrealism. A movement in art which began as a movement in literature. It attempts to show the reality in back of appearances, particularly in a

psychological sense. Surrealism uses the images of dreams, fantasy and sub-conscious thinking. Some surrealist artists express themselves through abstraction (see Matta's untitled etching, page 9). Others use a figurative or representational style (see Batlle Planas's *Composition*, page 89).

tempera. A paint made of pigment ground in water and mixed, or tempered, with a gelatinous matter, often egg.

triptych. A painting in three parts, hinged together or arranged side by side. Very often used for religious altarpieces. (See Hurtado's *Triptych: Mars-Venus-Mercury*, in the color insert.)

volume. Three-dimensional aspect of forms and figures.

watercolor. A paint made with ground pigment and water-soluble binder and used with water. The paint is transparent and the paper produces the highlights.

woodcut. A print made from a soft block of wood, cut away from the grain. It is carved so that the parts not cut away create the picture or design when ink is applied.

wood engraving. A print made from the end surface of a hardwood block. Lines are incised or grooved into the wood to produce the picture or design after the ink is applied.

Bibliography

Accents are supplied regardless of their appearance in the source cited.

• General Works

Alloway, Lawrence. "Latin America and International Art." *Art in America* (June 1965): 64–77.

_____. "The Search for a Legible Iconography." *Art Forum* (Oct. 1972): 74.

Arciniegas, German. *Latin America; A Cultural History.* New York: Knopf, 1970.

Arnheim, Rudolph. *Art and Visual Perception.* Berkeley: University of California Press, 1974.

Art of the Americas. Art News Annual XVIII. New York: The Art Foundation, 1948.

"Artistas Latinamericanos." *M.D.* (Jan. 1966): 180–6.

Bayón, Damián. *Artistas Contemporaneos de America Latina.* Paris: Ediciones del Serbal, UNESCO, 1981.

_____. "When Will Art of Latin America Become Latin American Art?" *Artes Visuales* (April–June 1976): 56–9.

Castedo, Leopoldo. *A History of Latin American Art and Architecture.* New York: Praeger, 1969.

Catlin, Stanton L., and Terrence Grieder. *Art of Latin America Since Independence.* New Haven, Conn.: Yale University Press, 1966.

Chase, Gilbert. *Contemporary Art in Latin America.* New York: Free Press, 1970.

Christ, Ronald. "Modern Art in Latin America." *Artscanada* (Dec.–Jan. 1979–1980): 47–55.

Duncan, Barbara, and Damián Bayón. *Recent Latin American Drawings.* Catalog to exhibition by the same name, organized by International Exhibitions Foundation, Washington, D.C., 1977.

Edwards, Emily. *Painted Walls of Mexico.* Austin: University of Texas Press, 1966.

Felguerez, M. "The Necessary Plurality of Latin American Art." *Artes Visuales* (April–June 1976): 6–7, 51.

Fernández, Justino. *Guide to Mexican Art.* Chicago: University of Chicago Press, 1969.

Findlay, James A. *Modern Latin American Art: A Bibliography.* (Art Reference Collection, No. 3.) Westport, Conn.: Greenwood Press, 1983.

Franco, Jean. *The Modern Culture of Latin America.* Great Britain: Pelican Books, Penguin Books, Ltd., 1970.

García Cisneros, F. *Latin American Painters in New York.* New York: F. García Cisneros, 1964.

Goldman, Shifra M. *Contemporary Mexican Painting in a Time of Change.* Austin: University of Texas Press, 1980.

Gómez-Sicre, José. "Dibujos Latinoamericanos." *Art News* (Oct. 1946): 40ff.

Harmon de Ayoroa, Jane. "Latin American Art at the Hirshhorn." *Américas* (Jan. 1976): 16–18.

Hunter, Sam. "The Córdoba Bienal." *Art in America* (March 1967): 84.

Jacobs, Jay. "Art in Puerto Rico." *Art Gallery* (Dec. 1967).

Kaiden, Nina, et al., eds. *La Nueva Vida: The New Life.* New York: Renaissance Editions, 1966.

Kirstein, Lincoln. *The Latin American Collection of the Museum of Modern Art.* New York: Museum of Modern Art of New York, 1943.

Looking South: Latin American Art in New York Collections. New York: Center for Inter-American Relations, 1972.

Messer, Thomas M. *The Emergent Decade. Latin American Painters and Painting in the 1960's.* Ithaca, N.Y.: Cornell University Press, 1966.

_____. "Latin American Esso Salon of Young Artists." *Art in America* (Oct. 1965): 120–21.

Museum of Modern Art of New York. *Contemporary Painters and Sculptors As Printmakers.* Ed. by Elaine L. Johnson. New York: Museum of Modern Art, 1966.

New York Graphic Society. *The Pocket Dictionary of Art Terms.* Ed. by Julia M. Ehresmann. New York: New York Graphic Society, 1971.

Pellegrini, Aldo. *New Tendencies in Art.* New York: Crown, 1966.

Phaidon Dictionary of 20th Century Art. New York: Phaidon, 1973.

Reichardt, J. "Latin American Art: Art and Metaphor." *Arts Review* (Feb. 18, 1977): 115–18.

Romero Brest, Jorge. "South American Art Today." *New Art Around the World.* New York: Abrams, 1966.

Schoen, Elin. "Emerging Art of Puerto Rico." *The American Way* (May, 1973): 12–17.

Squirru, Rafael. *Argentine Painting.*Catalog to exhibition by the same name. Buenos Aires: Instituto de Arte Moderno, 1959.

_____. "Contemporary Art in South America." *Connoisseur* (May 1975): 43–50.

_____. "Spectrum of Styles in Latin America." *Art in America* (Feb. 1964): 81–86.

Taylor, John F.A. *Design and Expression in the Visual Arts.* New York: Dover, 1964.
Taylor, Joshua C. *Learning to Look.* Chicago: University of Chicago Press, 1957.

• Manuel Álvarez Bravo

Badger, G. "The Labyrinth of Solitude: The Art of Manuel Álvarez Bravo." *British Journal of Photography* (May 21, 1976): 424–8.
Cordoni, David. "Manuel Álvarez Bravo." *Art Week* (July 7, 1973): 9.
García Ponce, Juan. *Manuel Álvarez Bravo, Photographs, 1928–1968.* Catalog to exhibition by the same name. Mexico: Organizing Committee of the Games of the XIX Olympiad, Instituto Nacional de Bellas Artes, Palacio de Bellas Artes, 1968.
Hernández Campos, Jorge. *Manuel Álvarez Bravo, 400 Fotografías.* Mexico: Instituto Nacional de Bellas Artes, Palacio de Bellas Artes, Dept. de Artes Plásticas, 1972.
Herrera, Hayden. "Bravo!" *Nuestro* (March 1979): 39–43.
————. "Native Roots: Manuel Álvarez Bravo, Photographer of Mexico." *artscanada* (Oct.–Nov. 1979): 29–32.
Hughes, Langston. *Pictures More Than Pictures.* Catalog to exhibition, *The Work of Manuel Álvarez Bravo and Cartier Bresson.* Mexico: Galería de Exposiciones del Palacio de Bellas Artes, 1935.
MacLean, Isabel Álvarez. Interview with Dorothy Chaplik, Evanston, Ill., May 30, 1974, and Feb. 4, 1987.
Masuoka, Susan N. "Mexico's Master Image-Maker." *Américas* (July–Aug. 1984): 9–13.
Parker, Fred R. *Manuel Álvarez Bravo.* Catalog to exhibition by the same name. Pasadena, Calif.: Pasadena Art Museum, 1971.
Strand, Paul. "Manuel Álvarez Bravo." *Aperture* Vol. 13, No. 4 (1968): 2–10.

• Alejandro Arostegui

Chase, Gilbert. *Contemporary Art in Latin America.* New York: Free Press, 1970.
Gómez-Sicre, José. *Alejandro Arostegui of Nicaragua.* Catalog to exhibition by the same name. Washington, D.C.: Pan American Union, Feb.–March 1966.
————. "Art and Artifacts in Medellín." *Américas* (Nov.–Dec. 1972): 2–8.
Rodman, Selden. "Art in Central America Today." *Art in America* (Jan. 1966).

• Héctor Basaldúa

Chase, Gilbert. *Contemporary Art in Latin America.* New York: Free Press, 1970.
Héctor Basaldúa. Catalog to exhibition by the same name. Buenos Aires: Bonino Gallery, 1959.
Mujica Lainez, Manuel. *Basaldúa in 1953.* Catalog to exhibition by the same name. Buenos Aires: Bonino Gallery.
Pellegrini, Aldo. *Panorama de la pintura argentina contemporanea.* Buenos Aires: Editorial Paidós, 1967.
Pan American Union (Audio-Visual Unit). *Argentina: Ten Internationally Known Contemporary Artists.* Text accompanying slides, Set No. 73. Washington, D.C.: Pan American Union.
Phaidon Dictionary of Twentieth Century Art. New York: Phaidon, 1973.
Romero Brest, Jorge. "South American Art Today." *New Art Around the World.* New York: Abrams, 1966.
Villanueva, Amaro. Text for *El Maté* (portfolio). Buenos Aires: Editorial El Maté, 1964.

• Juan Batlle Planas

Argentine Republic Art Exhibition. Buenos Aires: Museo Nacional de Bellas Artes.
Baliari, Eduardo. "Dialogos con nuestros artistas." *Clarín* (Feb. 23, 1958): 2.
Fundación Banco Mercantil Argentino. *Juan Batlle Planas.* Buenos Aires: Fundación Banco Mercantil Argentino, 1970.
Juan Batlle Planas, Pinturas y Dibujos, 1935–1949. Buenos Aires: Instituto de Arte Moderno, 1949.
Mujica Lainez, Manuel. Preface for catalog to exhibition, *Juan Batlle Planas/Argentine Cultural Panorama.* Washington, D.C.: Argentine Embassy, 1965.
Pan American Union (Audio-Visual Unit). *Argentina: Ten Internationally Known Contemporary Artists.* Text accompanying slides, Set No. 73. Washington, D.C.: Pan American Union.
Romero Brest, Jorge. "South American Art Today." *New Art Around the World.* New York: Abrams, 1966.
Squirru, Rafael. *Argentine Painting.* Catalog to exhibition by the same name. Buenos Aires: Instituto de Arte Moderno, Nov. 1959.
Varela, Lorenzo. *Juan Batlle Planas/Argentine Cultural Panorama.* Catalog to exhibition of the same name. Washington, D.C.: Argentine Embassy, 1965.
Villanueva, Amaro. Text for *El Maté* (portfolio). Buenos Aires: Editorial El Maté, 1964.

• Cundo Bermúdez

Bermúdez, Cundo. Interviews with Dorothy Chaplik, San Juan, Puerto Rico, 1975 and 1978.

_____. Recorded interview with Ricardo Pau-Llosa, 1975 or earlier. Furnished by artist.

_____. *Secundino Bermúdez*. Unpublished autobiographical notes furnished by artist, 1975.

Gómez Reinoso, Manuel. "Arte Cubano en Neuva York." *Noticias de Artes* (July 1976): 6–7.

Gómez-Sicre, José. "Art and Artifacts in Medellín." *Américas* (Nov.–Dec. 1972): 2–8.

_____. "Dibujos Latinoamericanos." *Art News* (Oct. 1946): 40ff.

_____. "San Juan Muralists." *Américas* (Aug. 1971): 2–9.

Pan American Union. *Boletín de Artes Visuales #16* (Washington, D.C.: Pan American Union, 1967): 52.

Pau-Llosa, Ricardo. "Art in Exile." *Américas* (Aug. 1980): 3–8.

Portner, Leslie Judd. "Cuban Modern Painting." *Art in Latin America*. (Club and Study Fine Art Series.) Washington, D.C.: Pan American Union, 1950.

Recent Developments in Latin American Drawing. Catalog to exhibition by the same name. Chicago: Art Institute of Chicago, Aug.–Sept. 1987. Organized by Hispanic Image Foundation.

7 Cuban Artists. Catalog to exhibition by the same name. Washington, D.C.: Pan American Union, 1952.

• Antonio Berni

Antonio Berni. Catalog to exhibition by the same name. Miami: Miami Museum of Modern Art, May–June 1963.

"Artistas Latinoamericanos." *M.D.* (Jan. 1966): 180–186.

Chase, Gilbert. *Contemporary Art in Latin America*. New York: Free Press, 1970.

Gassiot-Talabot, Gerald. Text for catalog to exhibition, *Berni, 1922–1965*. Buenos Aires: Centro de Artes Visuales del Instituto Torcuato di Tella, 1965?

Grabados Argentinos. Catalog to exhibition by the same name. Buenos Aires: Museo Nacional de Bellas Artes, April–May 1967.

Pellegrini, Aldo. *New Tendencies in Art*. New York: Crown, 1966.

Phaidon Dictionary of Twentieth Century Art. New York: Phaidon, 1973.

Ragon, Michel. "Antonio Berni." *Artist's Proof* (Spring–Summer 1963): 18.

Romero Brest, Jorge. "South American Art Today." *New Art Around the World*. New York: Abrams, 1966.

Squirru, Rafael. "Antonio Berni." *Américas* (Oct. 1965): 20–29.

————. "Contemporary Art in South America." *Connoisseur* (May 1975): 43–50.

Zimmer, W. "Exhibition Review." *Arts Magazine* (June 1977): 37.

• Ruth Bess

"Art Exhibits at the OAS." *Américas* (April 1972): 46.

Bess, Ruth. Unpublished autobiographical notes and correspondence with Dorothy Chaplik, 1976–1987.

Contemporary Printmakers of the Americas. Catalog to traveling exhibition by the same name. Washington, D.C.: Organization of American States, 1976–1977.

Gómez-Sicre, José. *Engravings by Ruth Bess of Brazil.* Catalog to exhibition by the same name. Washington, D.C.: Organization of American States, 1972.

Johnson, Elaine L. "Young Printmakers in Latin America." *Art in America* (Jan. 1971).

Maia, Antonio. "...Prints of Rute Courvoisier." *Jornal do Brasil.* Rio de Janeiro: Jan. 15, 1968.

Pan American Union (Audio-Visual Unit). *Brazil: Ten Internationally Known Contemporary Artists.* Text accompanying slides, Set No. 74. Washington, D.C.: Pan American Union.

Tercera Bienal del Grabado Latinoamericano. Catalog to exhibition by the same name. San Juan, Puerto Rico: Instituto de Cultura Puertorriqueña, 1974.

Tucker, Ronnie. "Brazilian Art Show." *Weekend Herald.* Buenos Aires: Oct. 21, 1972.

Who's Who in Graphic Art. Zurich: Amstutz & Herdeg, 1962.

• Fernando Botero

Atkinson, Tracy. *Fernando Botero.* Catalog to exhibition by the same name. Milwaukee, Wis.: Milwaukee Art Center, 1966–67.

Bermúdez, José Y. "Seven Colombian Artists." *Américas* (Oct. 1973): 38–43.

"Botero Retrospective First in U.S." *Times of the Americas* (Jan. 2, 1980): 12.

Chase, Gilbert. *Contemporary Art in Latin America.* New York: Free Press, 1970.

Christ, Ronald. "Modern Art in Latin America." *Artscanada* (Dec.–Jan. 1979–80): 47–55.

Dreiss, H. "Fernando Botero." *Arts Magazine* (Nov. 1975): 5.

Fernando Botero. Catalog to exhibition by the same name. New York: Marlborough Gallery, 1972.

Gallwitz, Klaus. *Fernando Botero.* Catalog to exhibition by the same name. New York: Center for Inter-American Relations, 1969.

Hunter, Sam. *Botero.* Catalog to exhibition by the same name. New York: Marlborough Gallery, 1975.

McCabe, Cynthia Jaffee. *Fernando Botero.* Catalog to exhibition by the same name. Washington, D.C.: Hirshhorn Museum, 1979–1980.

Pan American Union (Audio-Visual Unit). *Works by Colombian Artists.* Text accompanying slides, Set No. 75. Washington, D.C.: Pan American Union.

Romero Brest, Jorge. "South American Art Today." *New Art Around the World.* New York: Abrams, 1966.

Sanjurjo de Casciero, Annick. "Botero: The Magic of Reality." *Américas* (Nov.–Dec. 1979): 29–35.

Squirru, Rafael. "Contemporary Art in South America." *Connoisseur* (May 1975): 43–50.

Traba, Marta. *Botero, Coronel, Rodón.* Catalog to exhibition by the same name. San Juan: Museo de la Universidad de Puerto Rico, 1975.

• Emilano Di Cavalcanti

Bardi, P.M. *The Arts in Brazil.* Milan: Milione, 1956.

_____. *O Modernismo no Brasil.* São Paulo: Sudameris, 1978.

_____. *New Brazilian Art.* New York: Praeger, 1970.

Castedo, Leopoldo. *A History of Latin American Art and Architecture.* New York: Praeger, 1969.

Catlin, Stanton L., and Terrence Grieder. *Art of Latin America Since Independence.* New Haven, Conn.: Yale University Press, 1966.

"Di Cavalcanti." *Habitat* (Mar. 1962): 29–31.

"Di Cavalcanti." *Habitat* (Dec. 1963): 70.

"Di Cavalcanti." *Habitat* (Mar. 1964): 96–7.

Chase, Gilbert. *Contemporary Art in Latin America.* New York: Free Press, 1970.

Edson de Andrade, Geraldo. "The Figure in Brazilian Painting." *Américas* (Nov.–Dec. 1981): 29–33.

"Emiliano Di Cavalcanti." Obituary. *Time* (Nov. 15, 1976).

Gómez-Sicre, José. "Dibujos Latinoamericanos." *Art News* (Oct. 1946): 40ff.

José Luis Cuevas

"Artistas Latinoamericanos." *M.D.* (Jan. 1966): 180–186.

Barnitz, J. "A Fresh Look at Mexico." *Arts Magazine* (Dec. 1969).

_____. Catalog for exhibition, *Young Mexicans.* New York: Center for Inter-American Relations, 1970–71.

Bermúdez, José Y. "On Laughter and Death: A Word with Cuevas." *Américas* (June–July 1975).

Chase, Gilbert. *Contemporary Art in Latin America.* New York: Free Press, 1970.

Christ, Ronald. "Modern Art in Latin America." *Artscanada* (Dec.–Jan. 1979–80): 47–55.

Cuevas, José L. *Self-Portrait with Model.* Foreword by José Gómez-Sicre. New York: Rizzoli, 1983.

Fuentes, Carlos. *El mundo de José Luis Cuevas.* New York: Tudor, 1969.

Goldman, Shifra M. *Contemporary Mexican Painting in a Time of Change.* Austin: University of Texas Press, 1981.

Gómez-Sicre, José. "The Cuevas Phenomenon." *Américas* (Nov.–Dec. 1978): 2–8.

_____. "The Cuevas Phenomenon." *Art International* (Jan. 1972): 22–8.

_____. *The Drawings of José Luis Cuevas from the Collection of José Gómez-Sicre.* Catalog to exhibition by the same name. New Paltz, N.Y.: College Art Gallery, State University College. Undated (1963?).

_____. *José Luis Cuevas.* Catalog to exhibition by the same name. New York: Borgenicht Gallery, 1978.

_____. *José Luis Cuevas.* Catalog to exhibition by the same name. Washington, D.C.: Museum of Modern Art of Latin America, Organization of American States, 1978.

_____. *José Luis Cuevas, the Artist As Printmaker.* Catalog to exhibition by the same name. Washington, D.C.: Pan American Union, 1963.

Hernández Campos, Jorge. "Cuevas y las estancias de la historia." Catalog for exhibition, *José Luis Cuevas, Ilustrador de su tiempo.* Mexico: Museo de Arte Moderno, Instituto Nacional de Bellas Artes, Nov. 1972.

Hurtado, Angel, director. "Reality and Hallucinations." 16mm film. Museum of Modern Art of Latin America, Audio Visual Program, Organization of American States.

Micha, René. "José Luis Cuevas." *Art International* (Jan. 1978).

Neuvillate, Alfonso de. "Two Young Rebels in Mexican Painting." *Art of the Américas Bulletin*, Vol. 2 (1967): 21–29.

Rodman, Selden. "What's Mexican in Mexican Art." *Art in America* (June 1963).

Soupault, P. *José Luis Cuevas.* Paris: Michael Brient, 1955.

Tasende, J.M. *Works by Moore, Chillida, Cuevas.* Catalog to exhibition by the same name. La Jolla, Calif.: Tasende Gallery, 1985.

Zabludovsky, J. *Charlas con pintores.* Mexico: Costa Amic, 1966.

• Pedro Figari

"Artistas Latinoamericanos." *M.D.* (Jan. 1966): 180–86.

Frank, Waldo. "Pedro Figari." *Free World* (March 1946): 53–4.
Kirstein, Lincoln. "Pedro Figari." *Magazine of Art* (March 1946): 104–7.
Looking South. Catalog to exhibition by the same name. New York: Center for Inter-American Relations, 1972.
Pan American Union. "Paintings by Pedro Figari." *Bulletin* (May 1946): 272–3. Washington, D.C.
_____. (Audio-Visual Unit). *Uruguay: Pedro Figari.* Text accompanying slides, Set No. 70. Washington, D.C.: Pan American Union.
"Pedro Figari." *Art News* (March 1946): 52.
Reed, Judith K. "Memorial Show Accorded Figari of Uruguay." *Art Digest* (March 15, 1946): 20.
Romero Brest, Jorge. "South American Art Today." *New Art Around the World.* New York: Abrams, 1966.
Stoddard, Veronica Gould. "The Essence of a Regional Lifestyle." *Américas* (Nov.–Dec. 1986): 51.

• Raquel Forner

Castedo, Leopoldo. *A History of Latin American Art and Architecture.* New York: Praeger, 1969.
Chase, Gilbert. *Contemporary Art in Latin America.* New York: Free Press, 1970.
Dupuy, Michel. *Raquel Forner.* Catalog to exhibition by the same name. Washington, D.C.: Corcoran Gallery of Art, 1974.
Merli, Joan. *Raquel Forner.* Buenos Aires: Poseidon, 1952.
Negri, Thomas Alva. "Raquel Forner: Space Age Artist." *Américas* (Sept. 1972): 25.
Pellegrini, Aldo. *Panorama de la pintura argentina contemporanea.* Buenos Aires: Editorial Paidós, 1967.
Read, Herbert. *Exhibition Raquel Forner.* London: Drian Galleries, April 1967.
Romero Brest, Jorge. "South American Art Today." *New Art Around the World.* New York: Abrams, 1966.
Squirru, Rafael. "Contemporary Art in South America." *Connoisseur* (May 1975): 43–50.
_____. "Raquel Forner." *Américas* (Aug. 1968): 6ff.

• Antonio Frasconi

Antonio Frasconi. Catalog to exhibition by the same name. Washington, D.C.: Pan American Union, 1949.
Antonio Frasconi. Catalog to exhibition by the same name. Cleveland: Print Club of Cleveland and the Cleveland Museum of Art, 1952–53.

Antonio Frasconi. Catalog to exhibition by the same name. Baltimore: Baltimore Museum of Art, 1963.

"Antonio Frasconi." *Artists Proof* (Spring–Summer 1963): 19.

Frasconi, Antonio. "Antonio Frasconi." *The Tiger's Eye,* No. 8 (1949): 59–60.

————. *Frasconi Against the Grain.* Text by Nat Hentoff. New York: Macmillan, 1974.

Heit, J. "Antonio Frasconi." *Arts Magazine* (Oct. 1979): 8.

Heller, S. "Antonio Frasconi." *Graphis* (March–April 1983): 76–89.

Varga, M. "Woodcuts by Antonio Frasconi." *American Artist* (Oct. 1974): 30–37.

• Marcelo Grassmann

Bardi, P.M. *New Brazilian Art.* New York: Praeger, 1970.

Berkowitz, Marc. *Gravadores Brasileiros.* Catalog to exhibition by the same name. New York: Center for Inter-American Relations, 1969.

Catlin, Stanton L., and Terrence Grieder. *Art of Latin America Since Independence.* New Haven, Conn.: Yale University Press, 1966.

Chase, Gilbert. *Contemporary Art in Latin America.* New York: Free Press, 1970.

Marcelo Grassmann of Brazil. Catalog to exhibition by the same name. Washington, D.C.: Pan American Union, 1960.

Pan American Union (Audio-Visual Unit). *Brazil: Ten Internationally Known Contemporary Artists.* Text accompanying slides, Set No. 74. Washington, D.C.: Pan American Union.

Romero Brest, Jorge. "South American Art Today." *New Art Around the World.* New York: Abrams, 1966.

Who's Who in Graphic Art. Zurich: Amstutz & Herdeg, 1962.

• Oswaldo Guayasamín

Aznar, J.C. *Oswaldo Guayasamín.* Barcelona: Poligrafa, 1973.

Dolinger, Jane. "I Posed for Guayasamín..." *Figure* (Winter 1959): 4–9, 68.

Dozier. "Bienal Winner." *Madrid Press Report* (12/20/55) to *Time, Inc.,* New York.

Gómez-Sicre, José. "Dibujos Latinoamericanos." *Art News* (Oct. 1946): 40ff.

Martin, Yolanda C. "Private World of Guayasamín." *Américas* (July–Aug. 1982): 9–13.

Ribodeneira, Edmundo. Text accompanying portfolio, *Guayasamín.* Quito, Ecuador: Caspicara. Undated (1968 or later).

Squirru, Rafael. "Guayasamín of Ecuador." *Américas* (Feb. 1975): 10–16.

————. "Contemporary Art in South America." *Connoisseur* (Oct. 1975): 43–50.

Townsend, E. Jane. "Ecuador's Guayasamín." *Times of the Americas* (Feb. 3, 1971): 5.

• Lorenzo Homar

Artists of Puerto Rico. Catalog to exhibition by the same name. Washington, D.C.: Pan American Union, 1957.

Chaplik, Dorothy. "Puerto Rican Printmaker: Lorenzo Homar." *Revista Chicano-Riqueña*. University of Houston (Winter 1981): 41–46.

Exposición retrospectiva de la obra de Lorenzo Homar. Catalog to exhibition by the same name. Puerto Rico: Museo de Arte de Ponce, 1978.

Exposición retrospectiva de la obra gráfica de Lorenzo Homar. Catalog to exhibition by the same name. San Juan, Puerto Rico: Museo de Artes Plásticas, 1970.

Homar, Lorenzo. Interview with Dorothy Chaplik, Puerto Rico, 1975.

Jacobs, Jay. "Art in Puerto Rico." *Art Gallery* (Dec. 1967).

Kaiden, Nina, et al., eds. *Puerto Rico: La Neuva Vida.* New York: Renaissance Editions, 1966.

Lorenzo Homar. Catalog to exhibition by the same name. Middletown, Conn.: Davison Art Center, Wesleyan University, Oct. 1971.

Primera Bienal de San Juan del Grabado Latinoamericano. Catalog to exhibition by the same name. San Juan, Puerto Rico: Instituto de Cultura Puertorriqueña, 1970.

Puerto Rican Prints, An Exxon Collection. Catalog to exhibition by the same name. New York: Pratt Graphics Center. Undated (1973 or later).

Schoen, Elin. "Emerging Art of Puerto Rico." *The American Way* (May 1973): 12–17.

Wagenheim, Kal. *Puerto Rico: A Profile.* New York: Praeger, 1973.

• Angel Hurtado

Chase, Gilbert. *Contemporary Art in Latin America.* New York: Free Press, 1970.

Delgado, Rafael. *La pintura de Angel Hurtado.* Caracas: Instituto Nacional de Cultura y Bellas Artes (No. 10), 1969.

Gómez-Sicre, José. "Art and Artifacts in Medellín." *Américas* (Nov.–Dec. 1972): 2–8.

Hurtado, Angel. Interviews with Dorothy Chaplik. Washington, D.C., 1974 and 1975.

Recent Developments in Latin American Drawing. Catalog to exhibition by the

same name. Chicago: Art Institute of Chicago, Aug.–Sept. 1987. Organized by Hispanic Image Foundation.

• Frida Kahlo

Breslow, Nancy. "Frida Kahlo: A Cry of Joy and Pain." *Américas* (March 1980): 33–39.

Breton, André. *Surrealism and Painting.* New York: Harper & Row, 1972.

Cardoza y Aragón, Luis. *Mexican Art Today.* Mexico: Fondo de Cultura Económica, 1966. (First English edition.)

Helm, MacKinley. *Modern Mexican Painters.* Freeport, N.Y.: Books for Libraries, 1968 (Harper & Row, 1941).

Herrera, Hayden. *Frida: A Biography of Frida Kahlo.* New York: Harper & Row, 1983.

————. *Frida Kahlo.* Catalog to exhibition by the same name. Chicago: Museum of Contemporary Art, 1978.

————. "Frida Kahlo: Her Life, Her Art." *Artforum* (May 1976): 38–44.

La mujer como creadora y tema del arte. Catalog to exhibition by the same name. Mexico: Museo de Arte Moderno, Chapultepec, 1975.

Mulvey, L., and P. Wollen. *Frida Kahlo and Tina Modotti.* Catalog to a traveling exhibition by the same name, organized by Whitechapel Art Gallery, London, 1983.

Rabiger, M. "Frida Kahlo and June Leaf." *New Art Examiner* (March 1978): 5.

Rivera, Diego, with Gladys March. *My Art, My Life.* New York: Citadel, 1960.

Sullivan, E.J. "Frida Kahlo in New York." *Arts Magazine* (March 1983): 90–92.

Treasures of Mexico from the Mexican National Museum. Catalog to traveling exhibition by the same name, presented by Armand Hammer Foundation, 1978.

Wolfe, Bertram D. *The Fabulous Life of Diego Rivera.* New York: Stein & Day, 1963.

• Wifredo Lam

Breton, André. *Surrealism and Painting.* New York: Harper & Row (Icon Ed.), 1972.

Castedo, Leopoldo. *A History of Latin American Art and Architecture.* New York: Praeger, 1969.

Chase, Gilbert. *Contemporary Art in Latin America.* New York: Free Press, 1970.

Christ, Ronald. "Modern Art in Latin America." *Artscanada* (Dec.–Jan. 1979–80): 47–55.

Dunlop, F. "Letter from Paris." *Arts Review* (April 29, 1983): 228.

Esteban, Claude. "Wifredo – the Magic of Daybreak." *Cultures*, Vol. IX, No. 1 (1983): 204.
Franco, Jean. *Modern Culture of Latin America*. Great Britain: Pelican Books, Penguin, 1970.
Gamez, Tana de. "The Position of the Artist in Cuba Today." *Art News* (Sept. 1964): 42–45ff.
Leiris, Michel. *Wifredo Lam*. New York: Abrams, 1972.
Looking South. Catalog to exhibition by the same name. New York: Center for Inter-American Relations, 1972.
Rubin, William S. *Dada, Surrealism and Their Heritage*. Catalog to exhibition by the same name. New York: Museum of Modern Art, 1968.
Sweeney, James Johnson. *Wifredo Lam*. Catalog to exhibition by the same name. South Bend, Ind.: University of Notre Dame Art Gallery, 1961.
Wifredo Lam. Catalog to exhibition by the same name. New York: Gimpel Gallery, 1970–1971.

• Mauricio Lasansky

Art of the Americas Bulletin, Vol. 2 (1967): 8–9.
Contemporary Printmakers of the Americas. Catalog to traveling exhibition by the same name, organized by Audio-Visual Unit, Organization of American States, 1976–1977.
Glueck, Grace. "Art Notes." *New York Times* (March 26, 1967): 24.
"Iowa's Printmaker." *Time* (Dec. 1, 1961).
Lasansky, M. *Lasansky: Printmaker*. Iowa City: University of Iowa Press, 1975.
Moser, J., I. Danoff, and J. Muhlert. *Mauricio Lasansky: A Retrospective Exhibition*. Catalog to exhibition by the same name. Iowa City: Museum of Art, University of Iowa, 1976.
Zigrosser, Carl. *Mauricio Lasansky*. New York: American Federation of Arts, 1960.

• Augusto Marín

Campos Parsi, Héctor. Catalog to exhibition, *Augusto Marín*. San Juan, Puerto Rico: Convento de Santo Domingo, April 1973.
Gómez-Sicre, José. "San Juan Muralists." *Américas* (Aug. 1971): 2–9.
Jacobs, Jay. "Art in Puerto Rico." *Art Gallery* (Dec. 1967).
Kaiden, Nina, et al., eds. *Puerto Rico, La Nueva Vida: The New Life*. New York: Renaissance Editions, 1966.
Marín, Augusto. Interview with Dorothy Chaplik, Puerto Rico, 1975.

Who's Who in Graphic Art. Zurich: Amstutz & Herdeg, 1962.

• Marisol

Barnitz, Jacqueline. "The Marisol Mask." *Hispanic Arts* (Autumn 1967): 35ff.
Berman, A. "A Bold and Incisive Way of Portraying Movers and Shakers." *Smithsonian*, Vol. 14, Pt. II, (1984): 54–63.
Bernstein, R. "Marisol's Self-Portraits." *Arts Magazine* (March 1985): 86–89.
Campbell, L. "Marisol's Magic Mixtures." *Art News* (March 1964): 38ff.
Chase, Gilbert. *Contemporary Art in Latin America.* New York: Free Press, 1970.
Creeley, R. *Presences: A Text for Marisol.* New York: Scribner's, 1976.
D'Amico, M. *Nueve artistas venezolanos.* Catalog to exhibition by the same name. Caracas: Museo de Arte Contemporaneo, 1974.
Looking South. Catalog to exhibition by the same name. New York: Center for Inter-American Relations, 1972.
Loring, John. "Marisol Draws." *Arts Magazine* (March 1975): 66–67.
———. "Marisol's Diptych." *Arts Magazine* (April 1973): 69–70.
Marisol. Catalog to exhibition by the same name. Chicago: Arts Club, 1965.
"Marisol." *Midwestern Arts Review* (Feb. 1966): 33.
Shulman, L. *Marisol.* Catalog to exhibition by the same name. Worcester, Mass.: Worcester Art Museum, 1971.
Simon, J. "Chers Maîtres." *Art in America* (Oct. 1981): 120–1.
Werner, A. "Through the Golden Door." *Art and Artists* (Aug. 1976): 8–13.

• Matta

Abel, Lionel. "The Surrealists in New York." *Commentary* (Oct. 1981): 44–54.
Acha, J. "San Salvador." *Artes Visuales* (Summer 1977): 12–14.
Castedo, Leopoldo. *A History of Latin American Art and Architecture.* New York: Praeger, 1969.
Chase, Gilbert. *Contemporary Art in Latin America.* New York: Free Press, 1970.
Gómez-Sicre, José. "Dibujos Latinoamericanos." *Art News* (Oct. 1946): 40ff.
Looking South. Catalog to exhibition by the same name. New York: Center for Inter-American Relations, 1972.
Matta. Catalog to exhibition by the same name. Stockholm: Moderna Museet Stockholm, 1959.
"Matta's Surrealism on Paper." *Américas* (March–April 1984): 55.
Matthews, J.H. *Eight Painters.* New York: Syracuse University Press, 1982.
Miller, N. *Matta.* Catalog to exhibition by the same name. Waltham, Mass.: Rose Art Museum, Brandeis University, 1982.
Pellegrini, Aldo. *New Tendencies in Art.* New York: Crown, 1966.

Roberto Matta. Catalog to exhibition by the same name. La Jolla, Calif.: Tasende Gallery, 1980.

Romero Brest, Jorge. "South American Art Today." *New Art Around the World.* New York: Abrams, 1966.

Rubin, William. *Dada, Surrealism and Their Heritage.* Catalog to exhibition by the same name. New York: Museum of Modern Art, 1968.

_____. "Matta." *Bulletin of the New York Museum of Modern Art,* Vol. XXV, No. 1 (1957).

Simon, S. "Concerning the Beginnings of the N.Y. School." *Art International* (Summer 1967): 17–20.

Soby, James T. "Matta Echaurren." *Magazine of Art* (March 1947): 102–105.

Squirru, Rafael. "Contemporary Art in South America." *Connoisseur* (May 1975): 43–50.

• Carlos Mérida

Brenner, Anita. *Idols Behind Altars.* New York: Harcourt Brace, 1929.

Cardoza y Aragón, Luis. *Mexican Art Today.* Mexico: Fondo de Cultura Económica, 1966.

Charlot, Jean. *Art from the Mayans to Disney.* New York: Books for Libraries, 1969. (Original edition, 1939.)

Harithas, James. *Carlos Mérida.* Catalog to exhibition by the same name. New York: Martha Jackson Gallery, 1966.

Helm, MacKinley. *Modern Mexican Painters.* Freeport, N.Y.: Books for Libraries, 1968. (Original edition, Harper & Row, 1941.)

Looking South. Catalog to exhibition by the same name. New York: Center for Inter-American Relations, 1972.

Mendez Dávila, Lionel. *Guatemala.* (Art in Latin America Today Series.) Washington, D.C.: Pan American Union, 1966.

Mérida, Carlos. *Modern Mexican Artists.* Mexico: Frances Toor Studios, 1937.

_____. "My Present Technique." Catalog to exhibition, *Carlos Mérida.* Scottsdale, Ariz.: Gallery of Modern Art, 1964–65.

_____. "Self-Portrait." Catalog to exhibition, *Carlos Mérida.* New York: Center for Inter-American Relations, 1981.

Myers, B.S. *Mexican Painting in Our Time.* New York: Oxford University Press, 1956.

Nicholson, Irene. *Mexican and Central American Mythology.* New York: Paul Hamlyn, 1967.

Pollack, P. "Portrait of the Artist." Catalog to exhibition, *Carlos Mérida.* Scottsdale, Ariz.: Gallery of Modern Art, 1964–65.

Stoddart, Veronica Gould. "Mexican Master and Innovator." *Américas* (March–April 1982): 59.

• Pablo O'Higgins

Goldman, Shifra M. *Contemporary Mexican Painting in a Time of Change.* Austin: University of Texas Press, 1980.
Haab, Armin. *Mexican Graphic Art.* Teufen (A.R.) Switzerland: Niggli, 1957.
Helm, MacKinley. *Modern Mexican Painters.* Freeport, N.Y.: Books for Libraries, 1968. (Original edition, Harper & Row, 1941.)
Mérida, Carlos. *Modern Mexican Artists.* Mexico: Frances Toor Studios, 1937.
Reed, Alma M. *The Mexican Muralists.* New York: Crown, 1960.
Stewart, Virginia. *45 Contemporary Mexican Artists.* Stanford, Calif.: Stanford University Press, 1951.

• José Clemente Orozco

Brenner, Anita. *Idols Behind Altars.* New York: Harcourt Brace, 1929.
Cardoza y Aragón, Luis. *Mexican Art Today.* Mexico: Fondo de Cultura Económica, 1966. (First English edition.)
Charlot, Jean. *Art from the Mayans to Disney.* New York: Books for Libraries, 1978. (Original edition, 1939.)
Fernández, J. *Art Institute of Chicago Quarterly,* Vol. XLV, No. 4 (Nov. 15, 1951).
————. *Guide to Mexican Art.* Chicago: University of Chicago Press, 1969.
Goldman, Shifra M. *Contemporary Mexican Painting in a Time of Change.* Austin: University of Texas Press, 1980.
Helm, MacKinley. *Modern Mexican Painters.* Freeport, N.Y.: Books for Libraries, 1968. (Original edition, Harper & Row, 1941.)
Marrozzini, L. *Orozco: Obra gráfica completa.* San Juan, Puerto Rico: Instituto de Cultura Puertorriqueña, University of Puerto Rico, 1970.
Mérida, Carlos. *Modern Mexican Artists.* Mexico: Frances Toor Studios, 1937.
Orozco, José Clemente. *The Artist in New York.* Austin: University of Texas Press, 1974.
————. *José Clemente Orozco: An Autobiography.* Austin: University of Texas Press, 1962.
Orozco. Catalog to exhibition by the same name. Oxford, England: Museum of Modern Art, 1980–1981.
Quirarte, J. *Mexican American Artists.* Austin: University of Texas Press, 1973.
Reed, Alma M. *The Mexican Muralists.* New York: Crown, 1960.
Rich, Daniel Catton. "Orozco Fiesta in Mexico." *Art News* (May 1947): 15–17ff.
Roberts, Estelle Caloia. "Los Cuatro." *Américas* (June–July 1977): 38–44.

Rodríguez, Antonio. *History of Mexican Mural Painting*. New York: Putnam, 1969.

Schmeckebier, L.E. *Modern Mexican Art*. Minneapolis: University of Minnesota Press, 1939.

Smith, Bradley. *Mexico; A History in Art*. Garden City, N.Y.: Doubleday, 1968.

Stewart, Virginia. *45 Contemporary Mexican Artists*. Stanford, Calif.: Stanford University Press, 1951.

Sweet, Frederick. *Bulletin of the Art Institute of Chicago*, Vol. XXXV, No. 6 (Nov. 1941).

Treasures of Mexico from the Mexican National Museum. Catalog to traveling exhibition by the same name, presented by Armand Hammer Foundation, 1978.

• María Luisa Pacheco

"Andean Artist." *Time Latin America* (Aug. 19, 1957): 27.

Angel, Félix. "The Work of María Luisa Pacheco." Catalog to exhibition, *Tribute to María Luisa Pacheco of Bolivia*. Washington, D.C.: Museum of Modern Art of Latin America, 1986.

Artes Visuales. Pan American Union (Boletín #2, 1957–58): 5.

Castedo, Leopoldo. *A History of Latin American Art and Architecture*. New York: Praeger, 1969.

————. *Pacheco*. Catalog to exhibition by the same name. New York: Lee Ault, 1974.

Chase, Gilbert. *Contemporary Art in Latin America*. New York: Free Press, 1970.

García Cisneros, F. *Latin American Painters in New York*. New York: García Cisneros, 1964.

María Luisa of Bolivia. Catalog to exhibition by the same name. Washington, D.C.: Pan American Union, 1957.

"María Luisa Pacheco." *Art News* (Sept. 1965): 19.

"Pacheco." *Art News* (Dec. 1968): 52.

"Pacheco." *Arts Magazine* (Nov. 1967): 56.

Romero Brest, Jorge. "South American Art Today." *New Art Around the World*. New York: Abrams, 1966.

Sanjurjo de Casciero, Annick. "The Abstract Landscapes of Pacheco." *Américas* (Jan.–Feb. 1987): 14ff.

• Amelia Peláez

Barr, Alfred H. "Modern Cuban Painters." *Bulletin of the New York Museum of Modern Art* (April 1944): 2–14.

Chase, Gilbert. *Contemporary Art in Latin America.* New York: Free Press, 1970.

Gamez, Tana de. "Position of the Artist in Cuba Today." *Art News* (Sept. 1964): 42–45ff.

Gómez-Sicre, José. "Dibujos Latinoamericanos." *Art News* (Oct. 1946): 40ff.

_____. *Four Artists of the Americas.* Washington, D.C.: Pan American Union, 1957.

Portner, Leslie Judd. *Cuba.* Washington, D.C.: Pan American Union. (Art in Latin America Series.)

7 Cuban Painters. Catalog to exhibition by the same name. Washington, D.C.: Pan American Union, 1952.

• Emilio Pettoruti

Catlin, Stanton L., and Terrence Grieder. *Art of Latin America Since Independence.* New Haven, Conn.: Yale University Press, 1966.

Looking South. Catalog to exhibition by the same name. New York: Center for Inter-American Relations, 1972.

Morley, Grace L. McCann. "The Artist and His Exhibition." *San Francisco Museum of Art Quarterly Bulletin,* Vol. III, No. 2 (1944).

Pan American Union (Audio-Visual Unit). *Argentina: Ten Internationally Known Contemporary Artists.* Text accompanying slides, Set No. 73. Washington, D.C.: Pan American Union.

_____ (Division of Intellectual Cooperation). *Thirty Latin American Artists: Biographical Notes.* Washington, D.C.: Pan American Union, 1943.

Pellegrini, Aldo. *Panorama de la pintura argentina contemporanea.* Buenos Aires: Editorial Paidós, 1967.

Romero Brest, Jorge. "Emilio Pettoruti." *San Francisco Museum of Art Quarterly Bulletin,* Vol. III, No. 2 (1944).

_____. "South American Art Today." *New Art Around the World.* New York: Abrams, 1966.

Squirru, Rafael. "The Art of Emilio Pettoruti." *Américas* (April 1972): 25–30.

_____. "Contemporary Art in South America." *Connoisseur* (May 1975): 43–50.

• Candido Portinari

Bardi, P.M. *New Brazilian Art.* New York: Praeger, 1970.

Bulletin of the New York Museum of Modern Art, Vol. VII, No. 6 (Oct. 1940).

Carless, Rosa M. "Living Up to Brasilia." *Studio* (July 1963): 14–19.

Castedo, Leopoldo. *A History of Latin American Art and Architecture.* New York: Praeger, 1969.

Chase, Gilbert. *Contemporary Art in Latin America.* New York: Free Press, 1970.

Edson de Andrade, G. "The Figure in Brazilian Painting." *Américas* (Nov.-Dec. 1981): 29–33.

Honig, Edwin. "Portinari's New World Murals." *New Mexico Quarterly Review* (Spring 1943): 5.

Horn, Florence. *Portinari of Brazil.* Catalog to exhibition by the same name. New York: Museum of Modern Art, 1940.

Kent, Rockwell. Introduction to *Portinari: His Life and Work.* Chicago: University of Chicago Press, 1940.

Pan American Union (Division of Intellectual Cooperation). *Thirty Latin American Artists: Biographical Notes.* Washington, D.C.: Pan American Union, 1943.

————. *Brazil.* (Art in Latin America Series.) Washington, D.C.: Pan American Union, 1960.

———— (Audio-Visual Unit). *Brazil: Ten Internationally Known Contemporary Artists.* Text accompanying slides, Set No. 74. Washington, D.C.: Pan American Union.

Pedrosa, Mario. "From Brodowski to the Library of Congress." *Pan American Union Bulletin* (April, 1942 and May, 1942).

Smith, Robert C. "The Art of Candido Portinari." *Museum of Modern Art Bulletin* (Oct. 1940). New York: Museum of Modern Art.

————. *Portinari of Brazil.* Catalog to exhibition by the same name. New York: Museum of Modern Art, 1940.

————. "Murals by Candido Portinari in the Hispanic Foundation of the Library of Congress." *New Mexico Quarterly Review* (Spring 1943).

• Omar Rayo

"Embossed Prints by Omar Rayo." *Américas* (April 1975): 55.

Gómez-Sicre, José. "Art and Artifacts in Medellín." *Américas* (Nov.-Dec. 1972): 2–8.

Looking South. Catalog to exhibition by the same name. New York: Center for Inter-American Relations, 1972.

Moses, Paul. Exhibition review. *Chicago Daily News* (April 24, 1965).

Omar Rayo. Catalog to exhibition by the same name. Miami: Miami Museum of Modern Art, 1963.

Oniciu, A.P. *Omar Rayo Prints 1960–1970.* Bogotá, Colombia: Wittenborn, Italgraph.

Pan American Union (Visual Arts Unit). *Colombia: Ten Internationally Known*

Contemporary Artists. Text accompanying slides, Set No. 75. Washington, D.C.: Pan American Union.

Pizarro, Agueda. "Beyond the Gallery Wall." *Américas* (Jan.–Feb. 1984): 9–13.

Printmakers of the Americas. Catalog to traveling exhibition by the same name, organized by Organization of American States, 1976–77.

• Diego Rivera

Arquin, Florence. *Diego Rivera.* Norman: University of Oklahoma Press, 1971.

Canaday, John. "The Artist As Social Critic." *Metropolitan Seminar in Art.* Portfolio II. New York: Metropolitan Museum of Art, 1959.

Cardoza y Aragón, Luis. *Mexican Art Today.* Mexico: Fondo de Cultura Económica, 1966. (First English edition.)

Chase, Gilbert. *Contemporary Art in Latin America.* New York: Free Press, 1970.

Diego Rivera. Catalog to exhibition by the same name. The New York Museum of Modern Art. New York: W.W. Norton, 1931.

Edwards, Emily. *Painted Walls of Mexico.* Photographs by Manuel Álvarez Bravo. Austin: University of Texas Press, 1966.

Elitzik, Paul. "Discovery in Detroit: The Lost Rivera Drawings." *Américas* (Sept. 1980): 22–27.

Frances Toor Studios. *Frescoes.* (Mexican Art Series.) Mexico: Frances Toor Studios, 1937.

Freg, A. "The Legacy of Diego Rivera." *Artes de Mexico,* No. 179–180 (1975): 47–52ff.

Helm, MacKinley. *Modern Mexican Painters.* Freeport, N.Y.: Books for Libraries, 1968. (Original edition, Harper & Row, 1941.)

Lynch, J. "Rivera in Paris." *Américas* (Nov.–Dec. 1972): 30–36.

Myers, Bernard S. *Mexican Painting in Our Time.* New York: Oxford University Press, 1956.

Reed, Alma M. *The Mexican Muralists.* New York: Crown, 1960.

Rivera, Diego, with Gladys March. *My Art, My Life.* New York: Citadel, 1960.

_____, with Bertram D. Wolfe. *Portrait of Mexico.* New York: Covici-Friede, 1937.

Roberts, Estelle Calocia. "Los Cuatro." *Américas* (June–July 1977): 38–45.

Rodríguez, Antonio. Correspondence with Dorothy Chaplik, 1975.

_____. *A History of Mexican Mural Painting.* New York: Putnam, 1969.

The Rouge: The Image of Industry in the Art of Charles Sheeler and Diego Rivera. Catalog to exhibition by the same name. Detroit: Detroit Institute of Arts, 1978.

Stoddard, Veronica Gould. "Rivera Retrospective." *Américas* (May–June 1986): 55.

Treasures of Mexico from the Mexican National Museum. Catalog to traveling

exhibition by the same name, presented by Armand Hammer Foundation, 1978.

Wolfe, Bertram D. *The Fabulous Life of Diego Rivera.* New York: Stein & Day, 1963.

• Francisco Rodón

Barrenechea, Francisco. "Borges: Su primer retrato y sus confesiones." *Vanidades Continental* (Sept. 30, 1974): 61–64ff.

_____. *Personajes de Rodón.* Catalog to exhibition by the same name. Río Piedras, Puerto Rico: Museo de la Universidad de Puerto Rico, Dec. 1983–Jan. 1984.

Gómez-Sicre, José. "Art and Artifacts in Medellín." *Américas* (Nov.–Dec. 1972): 2–8.

Rodón, Francisco. Interview with Dorothy Chaplik, Puerto Rico, 1975.

Squirru, Rafael. "The Art of Portraiture of Francisco Rodón." Catalog to exhibition, *Personajes de Rodón.* Río Piedras, Puerto Rico: Museo de la Universidad de Puerto Rico, Dec. 1983–Jan. 1984.

_____. "Francisco Rodón: Painter of Puerto Rico." *Américas* (May 1974): 19–24.

Traba, Marta. *Botero, Coronel, Rodón.* Catalog to exhibition by the same name. San Juan, Puerto Rico: Museo de la Universidad de Puerto Rico, Nov. 1970.

Wagenheim, Kal. *Puerto Rico: A Profile.* New York: Praeger, 1973.

• Julio Rosado del Valle

Julio Rosada del Valle. Catalog to exhibition by the same name. Washington, D.C.: Pan American Union, 1965.

Rosado del Valle, Julio. Biographical notes (unpublished). 1975.

_____. Interview with Dorothy Chaplik, Puerto Rico, 1975.

Wagenheim, Kal. *Puerto Rico: A Profile.* New York: Praeger, 1973.

• Lotte Schulz

Esso Salon of Contemporary Latin American Artists. Coral Gables, Fla.: Lowe Art Museum, University of Miami, 1970–1971.

Retrospectiva de Lotte, 1956–1966. Catalog to exhibition by the same name. Asunción, Paraguay: Galería Ilari, Instituto Latinoamericano de Relaciones Internacionales.

Schulz, Lotte. Correspondence with Dorothy Chaplik, 1976–1980.
_____. Interviews with Dorothy Chaplik, Chicago, Ill., 1977–1980.
_____. "Michelangelo a través de la piedra." *Color ABC*, Suplemento Dominical. Asunción, Paraguay: Dec. 7, 1975.

• **Lasar Segall**

Bardi, P.M. *Lasar Segall*. São Paulo: São Paulo Museum of Art (printed in Milan: Edizioni del Milione), 1959.
_____. *New Brazilian Art*. New York: Praeger, 1970.
Castedo, Leopoldo. *A History of Latin American Art and Architecture*. New York: Praeger, 1969.
Chase, Gilbert. *Contemporary Art in Latin America*. New York: Free Press, 1970.
Ferraz, Geraldo. *Lasar Segall*. (Pinacoteca de los genios.) Buenos Aires: Ed. Codex S.A., 1964.
Milliet, Sergio. "Through the Eyes of Segall." *Américas* (Oct. 1951): 24.
New Art of Brazil. Catalog to exhibition by the same name. Minneapolis, Minn.: Walker Art Center, 1962.
Pan American Union (Division of Intellectual Cooperation). *Thirty Latin American Artists: Biographical Notes*. Washington, D.C.: Pan American Union.
Roth, C., ed. *Jewish Art*. New York: McGraw-Hill, 1961.
Smith, Robert C. "Lasar Segall of São Paulo." *Bulletin of Pan American Union* (May 1940): 382ff.

• **Guillermo Silva Santamaría**

Engravings by Guillermo Silva of Colombia. Catalog to exhibition by the same name. Washington, D.C.: Pan American Union, 1958.
"In the Galleries." *Arts Magazine* (May 1957): 60.
Ortega Ricaurte, Carmen. *Diccionario de artistas en Colombia*. Bogotá: Ediciones Tercer Mundo, 1965.
Silva Santamaría, Guillermo. Biographical notes. Furnished by Freed Gallery, Chicago.

• **David Alfaro Siqueiros**

Brenner, Anita. *Idols Behind Altars*. New York: Harcourt Brace, 1929.
Canaday, John. "Artist Who Outlived His Moment." *New York Times* (Jan. 7, 1974): 27.

Cardoza y Aragón, Luis. *Mexican Art Today.* Mexico: Fondo de Cultura Económica, 1966. (First English edition.)

Castedo, Leopoldo. *A History of Latin American Art and Architecture.* New York: Praeger, 1969.

Catlin, Stanton L. *David Alfaro Siqueiros.* Catalog to exhibition by the same name. New York: Center for Inter-American Relations, 1970.

Chase, Gilbert. *Contemporary Art in Latin America.* New York: Free Press, 1970.

Gual, Enrique. *Siqueiros.* Mexico: Ediciones Galería de Arte Misrachi, 1965.

Haab, Armin. *Mexican Graphic Art.* Teufen (A.R.) Switzerland: Niggli, 1957.

Looking South. Catalog to exhibition by the same name. New York: Center for Inter-American Relations, 1972.

Reed, Alma M. *The Mexican Muralists.* New York: Crown, 1960.

Roberts, Estelle Caloia. "Los Cuatros." *Américas* (June–July 1977): 38–45.

Rodríguez, Antonio. *History of Mexican Mural Painting.* New York: Putnam, 1969.

Schulz, Franz. "In the Grand Manner. . . ." *Chicago Daily News,* "Panorama" (Jan. 8–9, 1972): 1ff.

Squirru, Rafael. "Siqueiros Polyforum." *Américas* (Oct. 1972): 12–19.

Stewart, Virginia. *45 Contemporary Mexican Artists.* Stanford, Calif.: Stanford University Press, 1951.

Treasures of Mexico from the Mexican National Museum. Catalog to traveling exhibtion by the same name, presented by the Armand Hammer Foundation, 1978.

Whitman, Alden. "Siqueiros. . . ." Obituary. *New York Times* (Jan. 7, 1974): 27.

• Juan Soriano

Cardoza y Aragón, Luis. *Mexican Art Today.* Mexico: Fondo de Cultura Económica, 1966. (First English edition.)

Chase, Gilbert. *Contemporary Art in Latin America.* New York: Free Press, 1970.

"Juan Soriano. . . ." Essays by Juan García Ponce, Octavio Paz, and Diego de Mesa. *Artes Visuales,* No. 3 (Verano 1974): 46ff.

Kirstein, Lincoln. *The Latin American Collection of the Museum of Modern Art.* New York: Museum of Modern Art, 1943.

"Mexican Painting at OAS." *Américas* (Jan. 1979): 55.

Mexico. (Life World Library.) New York: Time, Inc., 1961.

Myers, Bernard S. *Mexican Painting in Our Time.* New York: Oxford University Press, 1956.

Stewart, Virginia. *45 Contemporary Mexican Artists.* Stanford, Calif.: Stanford University Press, 1951.

• Jesús-Rafael Soto

Barnitz, Jacqueline. "Jesús-Rafael Soto." *Arts Magazine* (Nov. 1974): 25.

Castedo, Leopoldo. *A History of Latin American Art and Architecture.* New York: Praeger, 1969.

Chase, Gilbert. *Contemporary Art in Latin America.* New York: Free Press, 1970.

Diament de Sujo, Clara. *Venezuela.* (Art in Latin America Today.) Washington, D.C.: Pan American Union, 1962.

Harmon de Ayoroa, Jane. "Latin American Art at the Hirshhorn." *Américas* (Jan. 1976): 16–18.

Imber, Sofía. *Nueve artistas venezolanos.* Catalog to exhibition by the same name. Caracas: Museo de Arte Contemporaneo, 1974.

Jésus-Rafael Soto. Notes to exhibition by the same name. Washington, D.C.: Hirshhorn Museum, Smithsonian Institution, 1975.

Johnson, N. "Natural Grace in the Work of Jesús Soto." *Artscanada* (Feb.–March 1978): 3–16.

Looking South. Catalog to exhibition by the same name. New York: Center for Inter-American Relations, 1972.

Lucie-Smith, Edward. *Late Modern,* 4th ed. New York: Praeger, 1974.

Pellegrini, Aldo. *New Tendencies in Art.* New York: Crown, 1966.

Pineda, Rafael. "Imágenes de Caracas." *Viasar* (Sept.–Oct. 1976): 14ff.

Romero Brest, Jorge. "South American Art Today." *New Art Around the World.* New York: Abrams, 1966.

Soto. Catalog to exhibition by the same name. New York: Marlborough-Gerson Gallery, 1969.

Soto: A Retrospective Exhibit. New York: Guggenheim Museum, 1974.

Squirru, Rafael. "Contemporary Art in South America." *Connoisseur* (May 1975): 43–50.

Stoddart, Veronica Gould. "Soto's Moving Art." *Américas* (Jan.–Feb. 1984): 54–5.

• Fernando de Szyszlo

Alloway, Lawrence. "Latin America and International Art." *Art in America* (June 1965).

Catlin, Stanton L., and Terrence Grieder. *Art of Latin America Since Independence.* New Haven, Conn.: Yale University Press, 1966.

Chase, Gilbert. *Contemporary Art in Latin America.* New York: Free Press, 1970.

Christ, Ronald. "Modern Art in Latin America." *Artscanada* (Dec.–Jan. 1979–1980): 47–55.

Fernando de Szyszlo. Catalog to exhibition by the same name. Washington, D.C.: Pan American Union, 1953.

Latin American Paintings. Catalog to exhibition by the same name. New York: Center for Inter-American Relations, 1969.

"Latin American Paintings. . . ." *Arts Magazine* (Sept. 1970).

Mason, J. Alden. *Ancient Civilizations of Peru,* rev. ed. Baltimore: Penguin Books, 1968.

Messer, Thomas M. *The Emergent Decade.* Ithaca, N.Y.: Cornell University Press, 1966.

Parker, Robert A. "Szyszlo's Abstract Nativism." *Américas* (Nov.–Dec. 1985): 41ff.

"Peruvian Mural." *Américas* (Oct. 1981): 47.

Romero Brest, Jorge. "South American Art Today." *New Art Around the World.* New York: Abrams, 1966.

Squirru, Rafael. "Contemporary Art in South America." *Connoisseur* (May 1975): 43–50.

"Szyszlo." *Studio Magazine* (April 1964): 167–68.

• Rufino Tamayo

Burr, J. "Images of Man." *Apollo* (Feb. 1982): 127.

Canaday, John. *New York Times* (Feb. 3, 1974): 21-D.

Cardoza y Aragón, Luis. *Mexican Art Today.* Mexico: Fondo de Cultura Económica, 1966. (First English edition.)

Chase, Gilbert. *Contemporary Art in Latin America.* New York: Free Press, 1970.

Christ, Ronald. "Modern Art in Latin America." *Artscanada* (Dec.–Jan. 1979–1980): 47–55.

Fernández, Justino. *A Guide to Mexican Art.* Chicago: University of Chicago Press, 1969.

Genauer, Emily. *Rufino Tamayo.* New York: Abrams, 1974.

————. "Rufino Tamayo." *Horizon* (June 1979): 38–47.

Goldman, Shifra M. *Contemporary Mexican Painting in a Time of Change.* Austin: University of Texas Press, 1981.

Goldwater, Robert. *Tamayo.* New York: Quadrangle Press, 1947.

Gómez-Sicre, José. *Four Artists of the Americas.* Washington, D.C.: Pan American Union, 1957.

Green, Eleanor Broome. "Tamayo: The Enigma and the Magic." *Américas* (March 1979): 38–44.

Helm, MacKinley. *Modern Mexican Painters.* Freeport, N.Y.: Books for Libraries, 1968. (Original edition, Harper & Row, 1941.)

Kingsley, April. "Magic from Mexico." *Newsweek* (June 4, 1979): 85–6.

Looking South. Catalog to exhibition by the same name. New York: Center for Inter-American Relations, 1972.

Messer, Thomas M. *The Emergent Decade.* Ithaca, N.Y.: Cornell University Press, 1966.

Myers, Bernard S. *Mexican Painting in Our Time.* New York: Oxford University Press, 1956.

Paz, Octavio. *Rufino Tamayo.* Mexico: Universidad Nacional Autonoma, Dirección General de Publicaciones, 1959.

Quirarte, J. *Mexican American Artists.* Austin: University of Texas Press, 1973.

Schmeckebier, Laurence E. *Modern Mexican Art.* Minneapolis: University of Minnesota Press, 1939.

Simpson, N.D. "Rufino Tamayo." *Southwest Art* (Sept. 1981): 58–67.

Stewart, Virginia. *45 Contemporary Mexican Artists.* Stanford, Calif.: Stanford University Press, 1951.

Westheim, Paul. *Tamayo.* Mexico City: Ediciones Artes de México, 1957.

• Joaquín Torres-García

Cassou, Jean. *Joaquín Torres-García.* Catalog to exhibition by the same name. New York: Rose Fried Gallery, 1960.

Castedo, Leopoldo. *A History of Latin American Art and Architecture.* New York: Praeger, 1969.

Chase, Gilbert. *Contemporary Art in Latin America.* New York: Free Press, 1970.

Kirstein, Lincoln. *Latin American Collection of the Museum of Modern Art.* New York: Museum of Modern Art, 1943.

Looking South. Catalog to exhibition by the same name. New York: Center for Inter-American Relations, 1972.

Pellegrini, Aldo. *Panorama de la pintura argentina.* Buenos Aires: Editorial Paidós, 1967.

Ratcliff, Carter. "New York Letter." *Art International* (Dec. 1977): 64.

Robbins, Daniel. *Joaquín Torres-García.* Catalog to exhibition by the same name. Providence: Rhode Island School of Design, 1970.

Squirru, Rafael. "Contemporary Art in South America." *Connoisseur* (May 1975): 43–50.

Stoddart, Veronica Gould. "Order and Symbol: Torres-García's Constructivism." *Américas* (Jan.–Feb. 1987): 57.

Suro, Dario. *Joaquín Torres-García.* Catalog to exhibition by the same name. New York: Rose Fried Gallery, 1965.

Tercera bienal del grabado latinoamericano. Catalog to exhibition by the same name. San Juan, Puerto Rico: Instituto de Cultura Puertorriqueña, 1974.

Torres-García and His Workshop. Catalog to exhibition by the same name. Washington, D.C.: Pan American Union, 1950.

Wheeler, Monroe. *Joaquín Torres-García.* Catalog to exhibition by the same name. Austin: University of Texas, Dec. 1971–Jan. 1972.

• José Antonio Velásquez

Algaze, Mario A. "The Artist As a Motif." *Américas* (Sept.–Oct. 1984): 2–7.
Castedo, Leopoldo. *A History of Latin American Art and Architecture.* New York: Praeger, 1969.
Gómez-Sicre, José. "Art and Artifacts in Medellín." *Américas* (Nov.–Dec. 1972): 2–8.
José Antonio Velásquez. Catalog to exhibition by the same name. Washington, D.C.: Pan American Union, 1954.
Lewis, William. "Velásquez: Honduran Painter." *Mankind* (Nov. 1979): 20–25ff.
Pan American Union (Audio-Visual Unit). *Naive Painters.* Text accompanying slides, Set. No. 80. Washington, D.C.: Pan American Union.

• Francisco Zúñiga

Castedo, Leopoldo. *A History of Latin American Art and Architecture.* New York: Praeger, 1969.
Chernow, Burt. "Francisco Zúñiga." *Arts Magazine* (Jan. 1978): 13.
Hancock de Sandoval, Judith. "Francisco Zúñiga." *Arts Magazine* (April 1977): 11.
Holden, Donald. "Immovably Centered. . . ." *Arts Magazine* (June 1983): 85–7.
Kirstein, Lincoln. *Latin American Collection of the Museum of Modern Art.* New York: Museum of Modern Art, 1943.
Reich, S. *Francisco Zúñiga: Sculptor.* Tucson: University of Arizona Press, 1980.
Rubicon Gallery. *Excerpts from a Conversation with Francisco Zúñiga.* Los Altos, Calif.: Rubicon Gallery, 1978.
Stewart, Virginia. *45 Contemporary Mexican Artists.* Stanford, Calif.: Stanford University Press, 1951.
Zúñiga, Francisco. *Zúñiga.* Introduction by Ali Chumacero. Mexico: Galería de Arte Misrachi, 1969.

Index